A History of Murston

A History of Murston

Bryan Clark

AMBERLEY

I would like to dedicate this book to all the past and present folk of Murston, especially those hard-working brickfield workers of days gone by.

First published 2011

Amberley Publishing
Cirencester Road, Chalford,
Stroud, Gloucestershire, GL6 8PE

www.amberleybooks.com

British Library Cataloguing in Publication Data.
A catalogue record for this book is available from the British Library.

ISBN 978 1 84868 998 5

Typesetting and origination by Amberley Publishing
Printed in Great Britain

Contents

Introduction

The name of Murston was supposed to be derived from Marsh Town, so called because of its close proximity to the marsh area of the river Swale and Creek. It was a scattered parish of 1,293 acres with three manors, the largest being Murston Court near the old church.

The area was rich farming land and there were also oyster fisheries. The community grew from a handful of workers to 128 in 1801. With the start of the brickfields in 1846 the population rose, and by 1851 numbered 191.

George Smeed built the industrial village of Lower Murston for his brickfield workers, and by 1921 Murston had a population of 1,603.

The manors were privately owned until the Smeed Dean Company bought them for the brick earth minerals.

Murston parish stretched from the River Swale at Elmley and the creek at Adelaide dock to the southern region main railway by the New Inn public house. The eastern boundary from the River Swale skirted West Tonge farm up to Docky Arch at the bottom of Tonge Road. A strip of land between Murston Road and the old George Street connected the parish to the glebe land where the rectory stood. Other parts of the parish included the Highsted Valley, glebe land at Luddenham and houses at Four Oaks near Faversham.

The parish was run by a parish council until 1930 when it was handed over to Sittingbourne Urban District Council. The parish was extended around 1950 to include the Canterbury Road Estate and is now administered by Swale Borough Council.

1

Murston

The Parish of Murston had three manor estates: Murston Manor, Meres Court and East Hall. The two farm houses of Meres Court and East Hall, once the manor houses, still exist. Murston Manor court house was pulled down in 1880, when the Smeed Dean Co. industrialised the area. The Parish was run by a council up until 1930, when it was disbanded and became part of the Sittingbourne Urban District Council, now Swale Borough Council.

An account of Murston is written in the 1908 Sittingbourne, Milton & District Directory as follows:

Murston is a populous and industrial village, situated three-quarters of a mile from the centre of Sittingbourne and adjoining that town. It is in the north-east Kent Parliamentary Division, the upper division of the Lathe of Scray, the Union and Hundred of Milton, the Sittingbourne County Court District, and the Sittingbourne Petty Sessional Division. It is 1293. 97 acres in extent and possesses three miles five furlongs of district roads. In the parish also are five acres of water, 23 of tidal water and 147 of foreshore. The population at the last census was 962, but this is now estimated to be 1,320, no less than 70 new houses having been erected in the parish since 1901. The rateable value is now £8,867. Murston possesses several miles of frontage on Milton Creek and the river Swale, and on large tracts of land near these waterways are situated the extensive brickfields and cement works of Messrs Smeed Dean and Co. Several portions of the parish are detached, one of them a narrow strip of land extending from Chilton Farm Sittingbourne, almost to Bottom Pond Frinsted. Another detached portion is situated at Four Oaks in the Faversham Union. Much of the soil of the parish is brick earth, and has been 'worked' for brick-making purposes.

The subsoil is chalk. Mr P. T. Herbert Wykeham is Lord of the Manor, and the principal land owners are the trustees of the estate of the late George Smeed. There is a ferry crossing the Swale from Murston to Elmley.

The parish church is dedicated to All Saints. The registry for baptisms dates from the year 1561 and for burials from 1562. The living, which is in the gift of St John's College, was of the net value of £450, with 45 acres of glebe and residence.

Elmley Ferry House

The original ferry crossing, which could take cattle as well as passengers, was replaced by a motor launch, which was used to ferry the Gransden children across from the island to go to Murston School. It ceased to operate in about 1950. The last ferryman was Jack Wade. Nobody occupied the ferry house or cottage after the 1953 floods, but a chap named Brown brought two old Mine sweepers and berthed them at the ferry. His family lived on one.

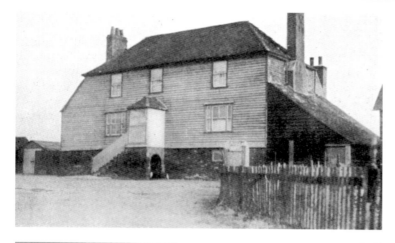

Elmley ferry house.

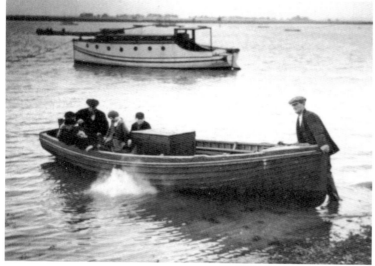

A ferryman at Elmley.

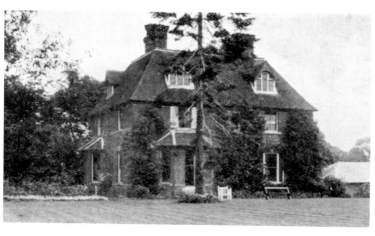

Murston Rectory.

Murston Rectory

The Rectory, built in 1867, stands in a fine timbered park of seventeen acres. The parish is in the Diocese of Canterbury, the Archdeaconry of Maidstone and the Rural Deanery of Sittingbourne.

The original Rectory pre-1866, previously the residence of Revd Poore, was unoccupied, and was being renovated for the new Vicar, when it caught fire and was destroyed in 1866.

The newly appointed Vicar, Revd Hoare, was instrumental in building the new Rectory in 1867 on the same site. It stood in a fine timbered park of seventeen acres, the southern side of the Parish on the other side of the main highway at Snipeshill.

The Rectory was pulled down in the 1960s, to make way for the houses adjoining Canterbury Road Estate.

A new Rectory house was then built in Portland Avenue, on the corner of Eagles Close named after a previous Murston Rector.

It is no longer the residence of the parish priest, who resides in Bapchild vicarage, officiating over the Parishes of Murston, Bapchild and Tonge.

I remember the old Rectory very well in the days of Revd Frank Eagles. It was the venue of many church fêtes, and also the choir parties at Christmas time.

Entrance to Rectory in Murston Park.

New Rectory in Portland Avenue built 1963.

2

Murston Village

The Parish of Murston was divided into three manors: Murston, Meres Court and East Hall. The latter two still exist as farmhouses although no longer having farms. The village of Lower Murston created by George Smeed for his brickfield workers has completely gone; the area and Meres Court have become industrial estates. East Hall is being developed into housing.

Murston manor house, named Court Lodge, was about 250 years old. It stood opposite the old church surrounded by a rich farm and homestead. The manor house was pulled down in 1880 as Murston industrial village expanded.

Originally, Smeed built two blocks of brick huts, nine in one and eleven in the other, on the west side of Church Road, opposite from where he started his first brickfield in 1846 on the east side, which is now Central Park. The huts were still there according to the 1901 census although they were uninhabited. They were later dismantled and the areas turned into rockeries with shrubs, trees and seats.

As the brickfields expanded Smeed built a block of eight houses opposite the old church in Gas Road, now Stadium Way. The first house was a shop and post office. Mr James Kift was listed as the Sub Postmaster in the 1901 census and 1908 Sittingbourne Directory.

He died in 1916 and the post office closed.

Smeed built a second block of ten houses on the eastern side of Church Road in front of the Old Church. The eighth house was built with one long downstairs room. This was used as a school up until the new school was built in 1868, further up Church Road. The old room was then used as a social club.

The ninth and tenth house front rooms were combined as a shop. Number ten had a bakehouse built at the rear of the premises. The 1881 census lists Thomas Farris a baker, living at number ten. By 1891 he was living at number nine, profession as a grocer/baker and Harry Farris, a grocer/baker's assistant, was living in number ten. The 1901 census and 1908 directory list Mr John Allen as the grocer, and later Mr Gilham owned the store. The front room of number nine became the post office sometime after 1916 when the one in Gas Road closed.

I remember Mrs Doris Field managed the grocery store and the post office for Mr Gilham up until it closed in 1965.

Next to the shop was a large alley leading to the bake house and the rear of the houses, which Smeed carried on building. From this alley he built, on the east side of Church Road, two more blocks of ten houses separated by a small alley between them. I was born in the third house of the block from the shop in 1937.

There was another large alley next to these two blocks which led down to the old disused brickfields. We called this the meadows, part of which, were allotments. From this alley he built another block of ten houses, then a block of fifteen. These blocks were separated by a small alley and were the last built on this side of the road.

The second house from the small alley in the block of ten was used as a shop in my younger days, run by Buff Hammond and his wife.

The old post office shows lighter bricks where the front was altered back to a dwelling house.

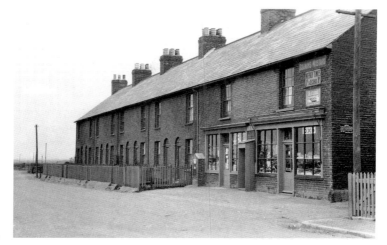

Second block of houses.

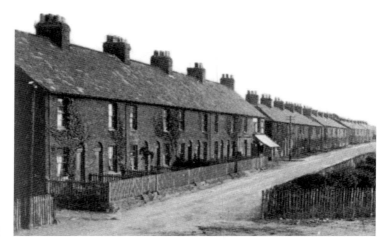

East Side of Church Road.

East side of Church Road in 2001.

Between the last block of fifteen and the recreation ground, there was originally a road to Meres Court. This was relocated to the other side of the recreation ground when Smeed dug brick earth around the farm which he bought in the 1890s.

The houses and gardens on this side of the road all stood where Central Park Stadium car park is now. The stadium originally built for Sittingbourne football club is now a greyhound venue. The Central Park building stands on the site of the old allotments and meadow's area. The race track is part of a field which was behind a row of Elm trees, between the meadows and Meres Court Farm. Sittingbourne football ground is now, what was their practice pitch behind the area used for boot fairs. This area was previously all orchards.

Old army hut.

The Recreation ground on the east side of Church Road, now Woodcombe Sports, had old army huts erected by the side of the road. These were used for accommodation around 1920. They were dismantled a few years later. I can remember the foundations were still there some years after.

On the far south west corner of the recreation ground stood the Murston social club erected in 1921 (*top of opposite page*). This was an old war time building from Throwley airfield. APCM bought the building in 1930 for use as a fully licensed works club. It was dismantled when the old stables were converted into a new works clubhouse in 1958. Woodcombe Sports are now the owners of the new clubhouse.

From 1875 on the west side of Church Road, Smeed built twelve houses from Gas Road up to the old brick huts. He had already built three blocks opposite the recreation ground, from the second block of old brick huts, with large alleys between each. The first was a block of six, then a

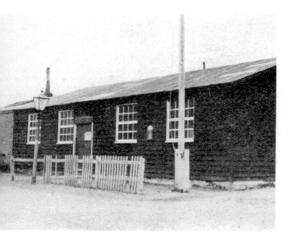

Murston social club. *Same site where the old club stood, 2008.*

block of ten. The last block only had eight. The last house of this block was used as a mission room, converting back to a dwelling in 1921. The Murston hand pump (later steam) fire engine was kept here, but I can only remember the local dust carts being kept in small buildings on the ground floor accessed from Church Road.

The block of six houses was reduced to three after a bomb exploded in one of the rear gardens, damaging the foundations of three which had to be pulled down. Between the old brick huts he built eight more houses. The old brick huts were eventually dismantled sometime after 1901 and turned into rockeries. The house seen on the far side of the rockery is one of the remaining three from the block of six.

The view along the right hand side of Church Road just shows the second rockery where one block of the old bricks huts used to be. The other block of huts, now a rockery, would have been on the other side of the eight houses.

The last block of eight houses to be built on the west side.

Above is the same west side view of Church Road taken in 2008, which is now Church Road Business Park opposite Central Park Stadium.

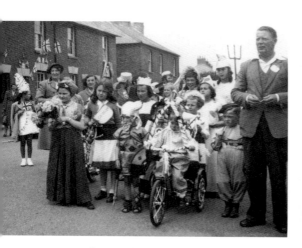
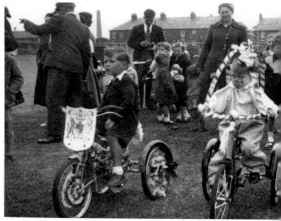

In 1953, Albert Henley organised the children of Murston in fancy dress, celebrating the coronation of Queen Elizabeth II. Both pictures show the houses on the west side of Church Road opposite the recreation ground.

After the old manor house was dismantled in 1880 eight more houses were built in Gas Road towards the creek. They were separated from the first block by a large alley, later to become a roadway which was called White Road. A narrow gauge railway ran through here supplying coal from the main line rail siding to the lower brickfields. This was discontinued after the war years.

There were already two houses below this last block called Rose Cottages, numbers one and two. These were built for the Gasworks Manager and Foreman around 1870; they became uninhabited during the 1900s. We, as local children, were always told they were haunted, basically to keep us away from playing there.

Between 1901 and 1908 a detached house was built between these two cottages and the last block in Gas Road. This was called Rose Villa. I remember Mrs Dalton living there in my childhood.

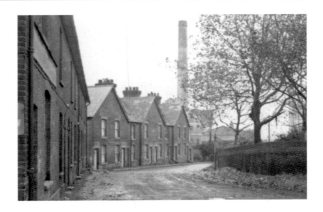

Second block of eight built in a different style.

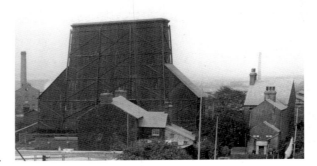

The wooden water cooler.

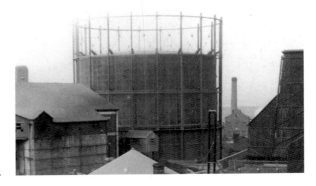

Gas Holder.

On the opposite side of Gas Road from Rose Cottages there stood a wooden water cooler. I remember two young Murston girls, Gloria Wood and Brenda Hudson, who were found drowned in the reservoir behind it.

The view of the water cooler shows the rear of the detached Rose Villa building on the right and the two Rose Cottages in front. Next to the water cooler was the gasworks built by George Smeed in 1853.

A path ran between the wall of the gasworks and the brickfield hacks of the old handberths. The wall is still visible. Murston residents used this path as a shortcut to the Brickmakers Arms public house, instead of walking down past the cement works and along to the right by the creek.

The Brickmakers Arms pub was built in 1859 by George Smeed for his workers and bargemen that used the wharves along the creek. I remember George (Biddy) and Ede Chesson when they were landlord and landlady of the pub, which closed in 1960. They had two sons William and Donald (Snowy). They also had a daughter, Mavis. William's son Richard was the last person occupying the premises running a car breaker's yard. The building has now become a private dwelling house owned by John and Kim Millen who have completely renovated it.

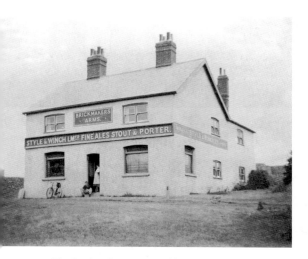

The Brickmakers Arms Public house, c. 1920s.

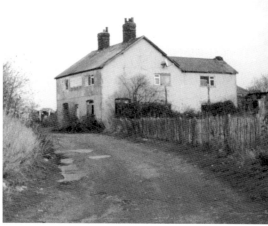

The Brickmakers Arms used as a car breakers, c. 1980s.

Brickmakers Arms showing creek bank raised.

Completely renovated as a dwelling house, 2008.

There were two new villas built in 1880, below the block of houses in front of the old church on the road to the lower brickfields. These were for the foremen of the company, now called Smeed Dean. Tom Barnes and George Hyland were the first occupants. The two foremen I remember living there were Mr Richardson, an electrician, and Mr Trevor Waters, a mechanical fitter.

During the 1900s a detached house was built next to the new villas. This was for the gasworks manager. I remember Mr Mann living there.

These three dwellings were still inhabited even after the village of Murston was demolished. From what I recall, Mrs Kempster and Mr Richardson's sons, Sid and Bob, were living in the villas and I think a person named Law was in the detached house. This was until they were pulled down to make way for the expansion of the Murston Industrial Estate.

This was then the unique village of Lower Murston. Sadly, all the houses were demolished during 1965/6 after residents were re-housed in the new Murston Estate from 1963, in the Tonge Road /Oak Road area.

The Gasworks Manager's house.

3

Murston Manor

At the time of the Norman Conquest a big part of Kent was granted to Bishop Odo. He was the half brother of William, Duke of Normandy, but in 1084, William the Conqueror as he became known, seized the estates of Bishop Odo and confiscated them to the crown for his seditious and turbulent behaviour (according to Hasted.)

The Manor of Murston was granted by William to Hugh de Port, one of the six knights who had come over with him in 1066. He also supplied the guard at Dover Castle for defence.

The Manor then passed to a Bartholomew de Murston, who assisted King Richard I at the siege of Acon in Palestine. His descendant, a John de Murston, held the Manor in the reign of King Edward III in 1347, of which he paid one Knights fee. Before the end of the reign of the next King, Richard II, (1377-99) the family became extinct.

A Walter Lord Fitzwalter was the owner in the reign of Henry VI (1422-53). Hasted states 'bearing for his arms, or, fefs between two chevrons, gules.' He seems to have transferred the property to Sir William Cromer, who was Lord Mayor 1413-1422 and when he died in 1433, the Manor passed to his female co-heir, who was married to John, the eldest son of Sir Edward Hales of Tenterden, Knight and Baronet. It continued in this family down to Sir Edward Hales Bart, of St Stephens near Canterbury. He later sold it to Rebecca, the widow of Sir Roger Twisden Bart, of Bradbourn in the late 1700s.

The living of the church was an appendage to the Manor owner, until Sir Edward Hales sold it to the Reverend Thomas Leigh, Rector of Murston 1732-74.

George Smeed bought Murston Manor Estate in about 1850. The Manor house stood on the opposite side of the road to the church, known as Gas Road and is now called Stadium Way. The area on the left just before the roundabout is where it once stood. There are no known photographs of the Manor house.

There is no mention of the Manor house in the 1881 census, owing to it being pulled down in about 1880. Later two blocks of eight houses were built on the left hand side of Gas Road and according to Sydney Twist's booklet, *Murston Village and Parish*, numbers 18–20 were where the Manor house had been. This was highly unlikely as there were only 19 houses in this road, two blocks of eight, Rose Villa and numbers 1 and 2 Old Gas Houses.

There was a farm originally behind the old church, which must have still been workable in the early 1800s. According to the 1851 census, David Cornford, who was a farm bailiff, lived in the Manor house known as Murston Court lodge, and Leonard England, a farm labourer, lived in Murston Court cottages, which must have been close by. The farm must have ended with the start of the Brickfields, because by 1861, John Wildash, who was a grocer, lived in the court lodge or Manor house and then Henry Sidders, a brickfield labourer, in 1871.

George Smeed, who owned Sittingbourne gasworks, which he built around 1839 at Crown Quay, moved the works to Murston in 1853 on land which was probably part of the farm. It was from about this time he started his Brickfields from the old church, down towards the marshes.

The site of the old Manor House, now Stadium Way.

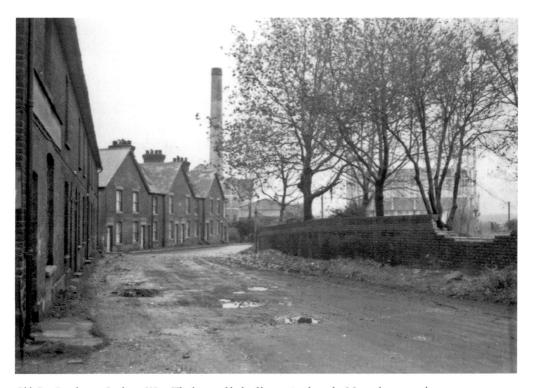

Old Gas Road, now Stadium Way. The bottom block of houses is where the Manor house stood.

4

Meres Court

Meres Court is an estate in the parish of Murston, once esteemed to be a capital mansion.

It appears not to have had any owners of that name, according to Hasted in his book about Kent. It was owned by Thomas Abelyn in King Edward I's reign, (1272-1307) of which he paid one Knight's fee. He died in 1276. His grandson, Thomas, succeeded him and his widow married Henry de Apulderfield, who possessed the Manor when young Thomas died in 1293. It then passed to the Savage family from Bobbing. Sir Arnold Savage died in 1376 and as his grandson had also died, his sister Eleanor became his heir. She married William Clifford Esq, in whose descendants it continued until it transferred to the Croft family. Daniel Croft, who died in 1580, left it to his daughters Helen and Margaret. They became joint heirs on his son John's death. They sold the Manor to Stephen Hulks in 1600. His descendant Nathaniel Hulks, died without a male heir, so his daughters Mary and Anne became co-heirs. Mary married a John Austen from St Martins Hill, near Canterbury, who died in possession of the Manor in 1770.

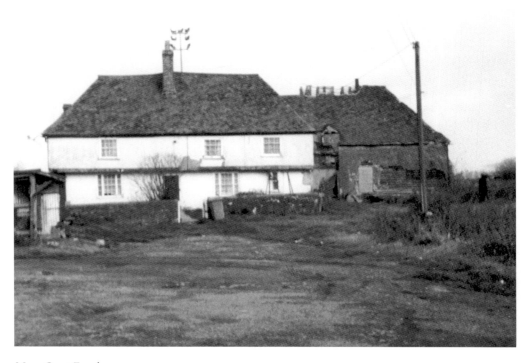

Meres Court Farmhouse.

Mary, who survived her husband, was entitled to his share and also to her sister's share when she died unmarried.

The Manor was sold by her descendants on her death in 1781 to John Lemmey, who was buried in the old church at lower Murston in 1828. His son George owned Meres Court, according to the 1841 and 1851 census. Then, after George died, it was said to be owned by the Staines Family, who had a letter S marked on their boundary stones. It seems from the 1861 census, Meres Court had George Lundruge, a labourer, living there and by the 1871 census, John Medhurst, employed as a farm servant, was living there and was still there in the 1881 and 1891 census.

Then, in 1901, John Bensted was living there. He died in 1922 and was buried in lower Murston old churchyard. He probably owned Meres Court after Staines, because Smeed Dean & Co purchased it from John Bensted in the late 1890s.

Smeed Dean & Co had tenant farmers, Lampell, Beacham and Betty Gates (Bert Bridges's daughter), during the 1950s–60s, then Triek Bridges 1960–1981. From 1981 to present time, David Gates, who descends from the Bridges family, the last tenant farmers, rented the farmhouse until 2009. The cottage, attached to the Farmhouse, now disused, was the home of a farm worker named Franklin during Beachams tenancy.

The owners from George Smeed & Co, were the Red Triangle, then Associated Portland Cement Manufacturers (APCM). The name then changed to Blue Circle, from whom Lafarge bought out the company. Trenport are the property owners who are developing the surrounding area as industrial.

The Farmhouse, although a Grade II listed building, is unoccupied at the time of writing and has been severly vandalised.

5
East Hall

East Hall, an estate in the parish of Murston, was once accounted as a Manor, as described by Hasted:

'The largest of the three Manors, it is a fifteenth century house but later extended by a brick built addition in the nineteenth century.'

A family named Easthall held the Manor in the reign of King Henry III (1216–72). Hasted states Joane de Easthall, is recorded in a book in Davington Priory, as being a good benefactor to the nuns there. After this family became extinct, it passed to the De La Pines (their crest bore three pineapples). One of their descendants, James De la Pine, who was a Sheriff of Kent, possessed the Manor and died in 1364. His son Thomas De La Pines, sold it to Thomas St Leger about the beginning of King Richard II's reign, (1377–99). It was his grandson Henry Aucher, who sold it to Humphry Eveas in 1442, who died in 1454. It then passed to his son John, who died in 1488.

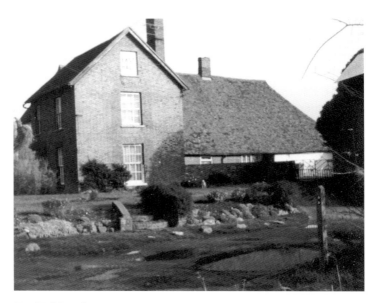

East Hall Farmhouse.

John Eveas lies buried in the old church at lower Murston in what was the north chancel. A brass commemorating his death and his family was removed from there in 1950 and relocated in the new Murston church next to the school.

It depicts a full face effigy of a bareheaded man in armour, a dog at his feet, also a side face figure of his wife Mildred and below are their three sons.

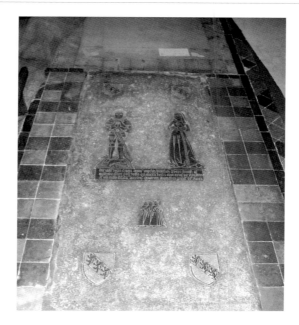

The inscription on the brass reads as follows,

> *John Eveas, late son of Eveas Knight and Mildred*
> *Consort of the said John, which same John died*
> *27th Nov. A.D. 1488 on whose souls God have mercy.*

It seems his wife Mildred, who survived John, remarried Lewis Clifford Esq, of Bobbing. She died in 1506, in possession of the Manor. Her grandson, Humphry Eveas, who died in 1536, left four daughters. One daughter, Alicia, married Thomas Hales, whose son Christopher transferred it to Sir Anthony Aucher of Otterden.

The following year, in 1552, he sold it to Thomas Gardyner. He in turn sold it to Mr John Norden in 1568, and then seven years later he sold it to William Pordage of Rodmersham.

Hasted states it continued in this family until it was sold to an Iles by a daughter. The name then went by marriage to Hazard, then to Shard, from whom it passed to Seath. Richard Seath owned the Manor in 1790.

In 1841 it was owned by Thomas White, who died in 1859. He was buried in the old churchyard at lower Murston, in a family grave which was surrounded by iron railings, partly destroyed due to vandalism. The Manor carried on in the White family, as the census of 1861/71/81 and '91 shows Harriet White, Thomas White's widow, farming the land. She employed sixteen men and two boys. After she died in 1892, her son William put the estate up for auction, which Smeed Dean & Co bought in the late 1890s. It was then farmed by tenant farmers. In the 1901 census, George Bourn, a Brickfield labourer, was living there. Then Len Baker farmed the land, as did Mr Parker. Mrs Bridges moved, into what is now just called a farmhouse, in the 1950s. Her daughter then moved from Meres Court to be with her in 1960 and was there until 2001.

Like Meres Court, owners from Smeed Dean & Co were Red Triangle and APCM, whose name was changed to Blue Circle Industries, later bought out by Lafarge. Trenport are now developing the East Hall area into an industrial and housing estate.

6
Murston Schools

The first purpose built school room in Murston appeared when George Smeed built houses for his Brickfield workers in Church Road, Lower Murston, opposite the old church.

One house had its downstairs room made into one long room. This was used as the school room, previous to which, the old church was probably used for teaching by curates, to supplement their income.

William Housson, Gent of the Parish of Bapchild, who died and was buried on 28 March 1783, gave and bequeathed the sum of £200 to be invested and the interest to be used for the purpose of educating a number of poor children from the Parishes of Tonge, Murston and Bapchild, in reading and writing the English language. The Parish of Tonge was always to have preference.

It was not until 1868 that Murston National School was founded and it opened in 1869.

On the appointment of the Revd J. S. Hoare as rector of Murston, he secured the help of the Church Diocesan Board in erecting a day and Sunday school for the Parish. The foundation stone was laid on 1 October 1868 by Mrs Hoare, the Rector's wife.

Mr Alfred Stump of Brompton was responsible for building the original buildings, which consisted of two school rooms, one 42 ft by 20 ft, the other 20 ft by 16 ft, with a house for the Master. The total cost was estimated at £1,000 which included purchase of the site, fencing and other items.

The principle room was used as a mixed school; the smaller room was devoted to the use of about 100 infants.

Three years later, in 1871, another school room, 42 ft by 20 ft, was added. The work was undertaken by Mr Henry Tidy of Sittingbourne, who had submitted the lowest tender. This room was also used to accommodate infants.

A concert was given by All Saints' church (old church); in aid of the building fund. A quote in the *East Kent Gazette* of 1871 stated: 'As the school room was used for the first time, we trust none of the company suffered from the dampness of the walls'.

By 1875 the total accommodation at Murston was 140 mixed scholars and 110 infants.

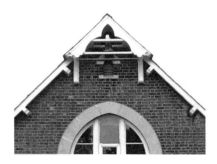

The original school building with bell.

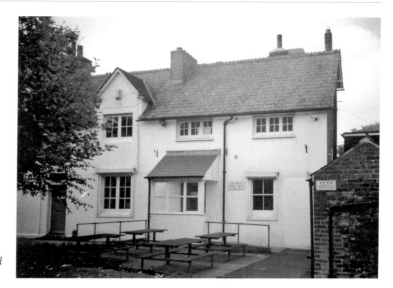

The Master's house which is now used as the school office. The upstairs chamber is used as a store room.

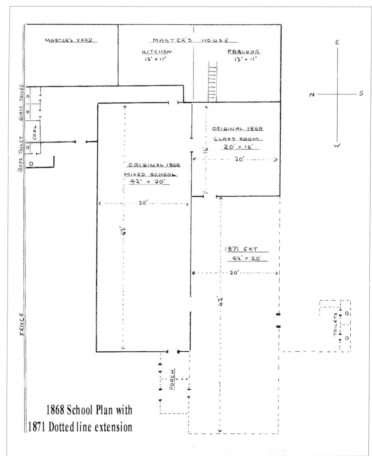

1868 School Plan with 1871 Dotted line extension

The original ground plan showing class room measurements.

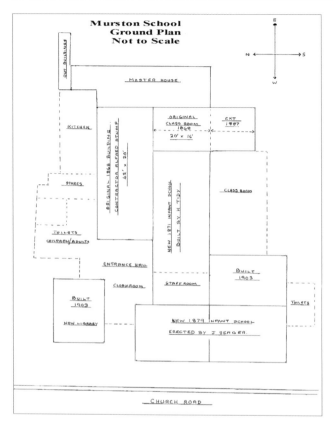

Murston School
Ground Plan
Not to Scale

Murston School ground layout plan as at 2008, the dotted lines showing the various alterations added to the main buildings.

A new infant school was added in 1879, built by Mr J. Seager, from the designs of Mr W. L. Grant. These rooms are on the western side of the original buildings, running along Church Road.

The opening of the new infant school was performed by the Bishop of Dover on the 20 November 1879.

The new school was to accommodate 150 scholars from Murston and the surrounding Parish of Sittingbourne.

The only enlargement since then was an extension to one of the classrooms in 1887 to enable another twenty scholars to be taken on, but with the growing population another two rooms were built in 1903, one facing south behind the infant school, the other at the north-west corner.

Again, in 1908, more improvements were made. New offices had been erected; toilets and cloakroom accommodation provided; heating the north rooms of the mixed and infant schools with fireplaces, and a partition inserted in the principle room of the mixed school.

By 1924, it was stated that the Murston Church of England mixed school required between £1,200 and £13,00 to bring the buildings up to the then present day requirements. The money would have to be found by voluntary means. The school managers, under the circumstances, decided to hand the school over to the Kent Education Committee, which then became Murston Council School.

For eighty-two years, Murston School taught boys and girls up to school leaving age, which increased from twelve years to fifteen years, but in 1950, all boys and girls from the age of twelve years had to go to the newly built Sittingbourne West Secondary Modern School for boys and girls, called Westlands, except those who passed the eleven plus exam, who could then go to either a Technical or

Grammar school. Murston School then had no children over the age of twelve years, which is when it was probably re-organised as an infant and junior school.

In 1959 preparations were made to provide new cloakrooms, toilets, staff room and a kitchen for the provision of meals.

I remember, as a child, having to carry our tables and chairs to the Parish Hall where school diners were cooked.

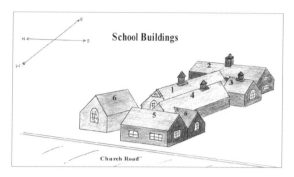

The original school room, numbered one, and the Master's house, numbered two, with an original classroom numbered three, was built in 1868 by Mr Alfred Stump, a contractor from Brompton.

In 1871 Mr H. Tidy of Sittingbourne built the classroom numbered four. The new Infant School, numbered five, was built by Mr J. Seager, also from Sittingbourne in 1879. The original classroom, numbered three, was extended in 1887. The two other buildings, both numbered six, were built in 1903.

A Mrs Peck, who was a cleaner at the school, applied for an increase in wages, when the two new rooms were built in 1903. The managers at the time resolved that 2/-s or 24 pence, old money, be given per week during school time, and 1/-s per week during holidays.

In 1928, the head teacher reported that under modern methods of teaching, it was necessary that if official work was to be done by standard 3 and 4, a class of eighty-four scholars, that a partition should be provided for the big classroom in order to divide the two classes working side by side.

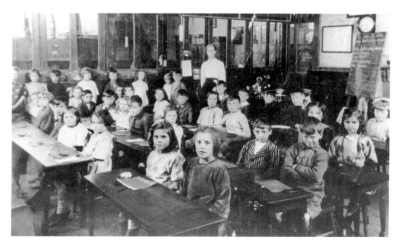

School Class, around 1933, with the partition in the background.

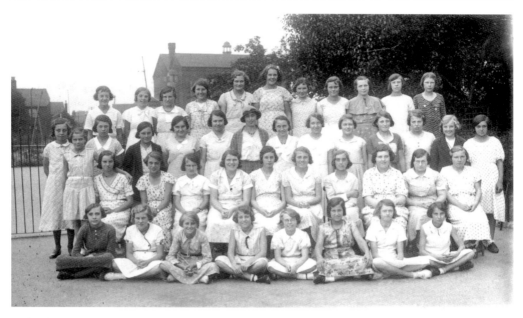

Girls' Class, 1934, with the teacher, Mrs High, in the centre.

One of the other buildings at Murston School was an air raid shelter. I remember having lessons in these during the Second World War, where we would be assembled when the sirens blew.

The old shelters are still in the playground but the boys' toilets, which were at the end on the right, have been removed. The end of the shelter is now for special needs children. The other end is used by the scouts. There were also girls' toilets along the fence by the school hollow to the left of the hollow steps. These have been removed.

Murston School playground.

Hollow steps to the school sports field, which are now kept locked.

After the alterations in 1959, the original foundation stone from the wall under the school bell was removed and re-laid in the wall at the front of the buildings by Mrs High, widow of a former Headmaster, Mr Richard High (whom I remember well).

Mrs High, also a former teacher, taught the older girl scholars.

Increased housing in Murston, from around 1963, saw the need for extra classrooms. Two wooden classrooms were erected on land turned into a playing field, which were previously school allotments for the boys.

My first encounter on the allotments as a ten-year-old was double digging, whereby two or three boys dug a trench 18 inches deep across a marked-out plot, lining it with manure and covering it with soil as the next trench was dug. Then, at the end of the afternoon lesson, we would have to clean and grease the fork or shovel that we had used, storing them in the old school allotment shed at the bottom of the hollow steps.

Apparently, girls had allotments during 1917 on land around the modern church, before it was consecrated for burials; prizes were given for the best kept garden.

Additional rooms have been erected, extending the building of the wooden classrooms; first a room built for The Murston Project in 2001, then a second extension which was opened by Mr Ian McKastney, Minister without Portfolio in 2004.

In 1966 a mobile classroom was delivered, costing about £2,000. It was assembled in about three hours and was originally sited along by the school fence in Tonge Road.

Other portable buildings were put on this site of the old school allotments, one especially used for the Poppyfields centre, which was opened by David Sargent in 1997; and has since been handed back to the school in 2006.

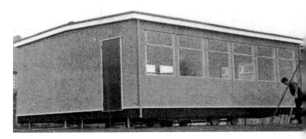

Right: *A mobile classroom.*
Below right: *Poppyfield Centre.*
Below left: *The two wooden classrooms.*

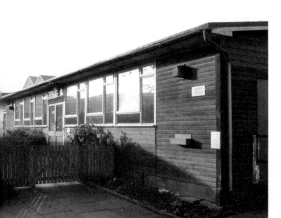

These pictures show both sides of the renovated building.

The building, used as the Poppyfield centre, which was handed back to the school in 2006, has been completely renovated inside and out. It opened in 2008 as a children's centre.

A new nursery and car park, built in 2006, was officially opened by former teacher and Governor, Margaret Wlazlak, as part of Murston Infant School. It provides nursery education for about fifty-two children; twenty-six in the morning and twenty-six in the afternoon.

The link between the nursery and the school will help overcome the transition for the children, as they start their primary education. It is a grant maintained nursery, funded by the Kent County Council nursery at a cost of £350,000.

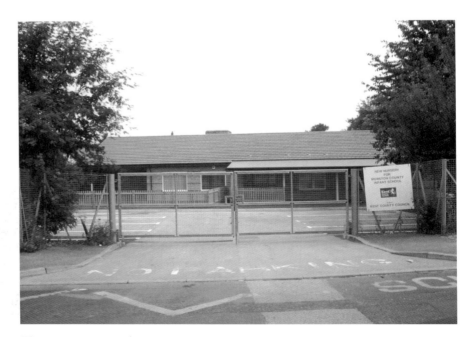

The new nursery car park.

During 2008, a new fence has been erected along Tonge Road in front of the Nursery. The old gates were also replaced.

MURSTON HEAD TEACHERS

1868 – 1875	Mr Thomas Lancaster Simpson	1958 – 1974	Mr Eric W. Garlick
1875 – 1878	Mr Alexander Rhees	1974 – 1975	Mr Frank Cotton Acting Head
1878 – 1880	Mr R. P. Hillier	1975 – 1977	Mrs Joan Seymore
1880 – 1882	Mr James Coleman	1977 – 1986	Mrs Murial Williams
1882 – 1924	Mr James Hales Pudney	1986 – 1987	Penny Foreman Acting Head
1924 – 1958	Mr Richard Thomas High	1987 –	Mrs Dot Bromley

(Years of Office ran concurrent although it depended on the school term for start.)

With the expansion of the population due to the new housing estate development in the Murston area, around Tonge Road, there was a need for a larger school.

A new school was built at Sunny Bank just off Church Road, and was opened in 1972. This now became Murston Junior School, catering for children of eight to eleven years of age.

The old school at Church Road then became Murston Infants School.

JUNIOR SCHOOL HEAD TEACHERS

1972 – 1974	Mr Garlick was head of both schools retiring in December
1975 – 1975	Mr Cotton was acting head for 6 months

(The Infant and Junior schools split into separate schools in 1975.)

1975 – 1991	Mrs B. Towsey
1991 – 2005	Mrs M. Cook
2005 –	Mrs M. Laming

Murston Junior School.

7
Old Church

Old Murston church was dedicated to All Saints, was mostly early English in design, and was built in the late twelfth or thirteenth century.

In Glynne's book *The Churches of Kent*, published by John Murray in 1877, he describes the church as being small, with a nave and chancel with side aisles, a wooden turret over the west end of the nave, and on the north side was a doorway with a shouldered arch. A bell of about 3 ½ cwt, cast by William Oldfield of Canterbury for the church in about 1560, was inscribed with I.H.S., a cross, lion passant and another cross. It was later removed to the new church when the old church was pulled down in 1873.

There are several rectors and their wives buried in the vaults under the floor, although some of the tombstones may have been realigned from their original positions.

The churchyard was used for burials until 1930. From then onwards all new burials were interred in the new cemetery, adjoining the new church further south from the village of Lower Murston.

The registry for baptism dates from 1561, and burials are dated from 1562.

The living is in the gift of St John's College and was of the net value of £450, with 45 acres of glebe and residence.

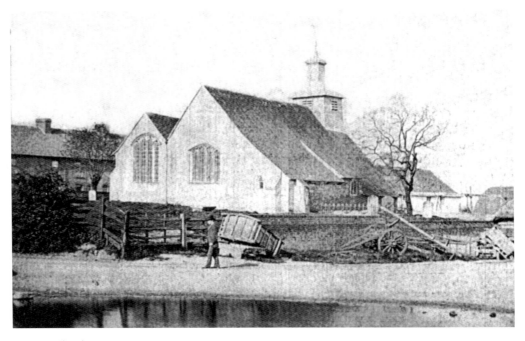

Murston Church, c. 1855.

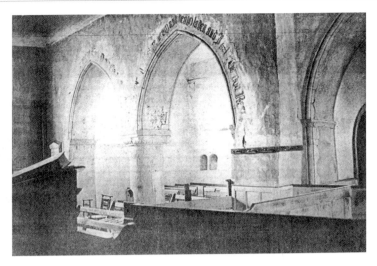

Arches in the South Nave.

The Nave was divided from each side by two pointed arches. The south side arches were early English, supported by a circular pier having a Norman capital. On the north side the arches were supported by an octagonal pier. The Chancel had two early English arches on each side, with piers like that of the south Nave. Written over one of the arches in the old All Saints' Church, seen before being partially dismantled, was a verse from the Holy Bible, Matthew, Chapter 11, Verse 28:

Come unto me, all ye that labour and are heavy laden, and I will give you rest.

The old church was in need of repair and considered to be unsafe. There were also fumes from the noxious industry close by the church, i.e. gasworks retorts and brick kilns made it difficult for the congregation to breathe, so the rector, Revd J. S. Hoare, started a fund to build a new church, donating £500 himself.

The old church was dismantled in 1873, and a new church was built further up Church Road next to the school.

Some parts of the church were used in the construction of the new church, for example, salvaged pieces of the circular pillars supporting the arches, a fifteenth century screen and some of the floor tiles.

All that remains of the old church is part of the centre chancel, which was used as a mortuary chapel.

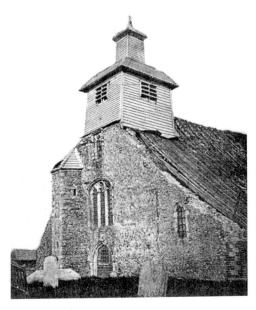

The old church, 1873.

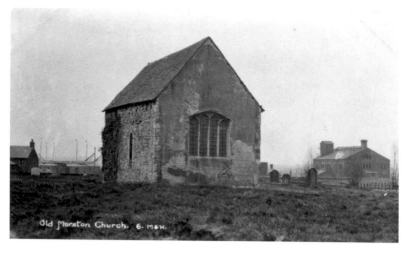

Old Murston Church. 6. M&H.

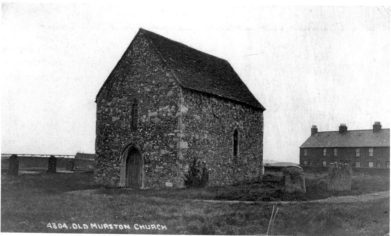

4804. OLD MURSTON CHURCH

These two postcards show the remains of the centre chancel. The top one shows the view from the east, with the offending gas retort building on the right and the old type cement kiln on the left, behind the houses built for the gas staff workers. The bottom postcard shows the view from the west. Neither card shows any trees around the boundary.

In 1930, when the Parish of Murston Council was disbanded, the parish was taken over by the Sittingbourne Urban District Council, now Swale Borough.

The church fell into disrepair and decay and was threatened with demolition. To avoid this, Michael Nightingale arranged for the church commissioners to convey the church and churchyard to a new trust in 1976, with trustees (of which he was one) appointed by the Kent Archaeology Society. The latter secured funding to repair and retile the roof and the west door in the mid-1980s. It was to be used by the scouts of Murston and Bapchild.

Further vandalism made continued occupation impossible. The Kent Archaeology Society felt it could do no more for the building, so Michael Nightingale persuaded his co-trustees on the Cromarty Trust, to retile the building again and undertake limited repairs to the stonework, with support from English Heritage and other organisations in the 1980s.

During 1995, after the old mortuary chapel had once again been restored, it was intended that the building should serve as the gateway for a Swale Heritage Trail, but it never materialised, although booklets are still available on the Swale Heritage Trail.

The churchyard is now surrounded by industry at the bottom of Church Road, and the old road in front of the church has been constantly plagued by travellers.

Kent Highways sealed the road off with concrete tubs in 2004, but even then travellers invaded and demolished about 23 metres of the boundary wall in March 2005.

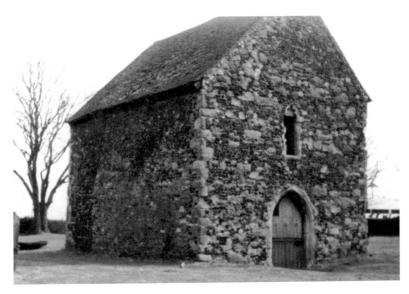

Part of the centre chancel showing arches outline.

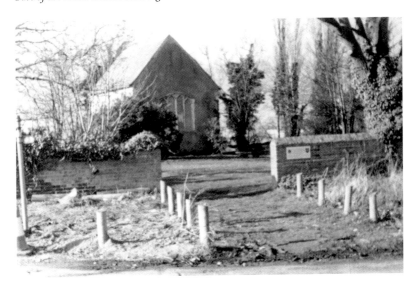

The remains of the old church.

8

New Church

Rebuilding

The work of building Murston's new church had commenced as reported in the *Gazette and Times* 19 April 1873, and on Tuesday evening, a public tea and entertainment took place in the school rooms, adjoining the site, in aid of the building fund. The rooms were tastefully draped with flags, lent by Mr George Smeed, who had given the site with 250 loads of flint and three barge loads of excellent building sand.

The Rector, the Revd J. S. Hoare, remarked they should congratulate each other on the fact that they were actually now beginning the work, which they had talked about for the past seven years. He said the work below ground took a great deal longer than that above. He had been working below ground for the last seven years and there was some prospect of it shortly rising above the ground.

The building work was undertaken by Messrs Adcock and Rees of Dover, from designs by Mr Burges of London, using cut flint in straight courses, with Bath stone dressings, and would comprise of a chancel with circular apse, nave and north isle and a tower, built in the early English style of architecture, the walls of three feet thickness with a tower surmounted by a spire, (the spire was not built, only a wooden belfry) total height 135 ft, the lower part constructed to form an organ chamber and vestry.

There was a ceremony in May 1873 for the laying of the foundation stone, in the presence of the Bishop of Dover and a large assemblage of Clergy and Laity of the Deanery.

The laying of the foundation stone was performed by Mr G. Smeed. Two minor stones were laid, one by Mrs Hoare, the other by Messrs Bensted and White (neither of these stones are visible). There is a white coloured stone at the base of one Tower Buttress facing east. There is no inscription that is visible, so it could be a later addition for some reason. There are no other stones in the vicinity that could identify it being a foundation stone. There is a brick extension on the north side of the church, covering that part of the Tower where the door led into the Vestry. It is possible the stones could have been there.

The trowel used for the ceremony was silver, prepared as a gift to the Hon A. McArthur, on laying the foundation stone of the Wesleyan school's enlargement the same week, and kindly lent by the Wesleyan friends for Murston Church.

The Church was completed by 1874 and was consecrated by the Archbishop of Canterbury on the 22nd of July.

The Organ, built expressly for the Church by Messrs Lewis & Co of Brixton, was opened on the occasion under the direction of F. Kinkee Esq, the organist of St Mary's, Lambeth. He also assisted at special services held in the following week. It was proposed in 1874 to hold a special service of thanksgiving in the church on All Saints' Day, Sunday 1 November; this being the name of the church.

The occasion was taken to celebrate the first festive of the church, with a harvest festival held at the same time. A sermon was preached by the Revd Canon Hilton, rector of Milsted.

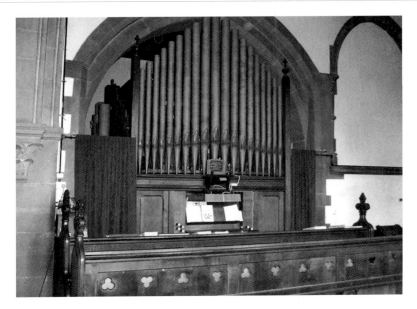

Church Organ.

The new church, built of flint and stone in the early English styles, is dedicated to All Saints, and stands next to the school in Church Road. It cost £3,000 to build.

Originally seating 300 persons it was opened for worship in July 1874, but the churchyard was not consecrated until 1922, by the Bishop of Dover, the Rt. Revd B. Hawkins.

The tower, which had two bells, was heightened, and the original wooden gable belfry was replaced by a flat roof in 1959.

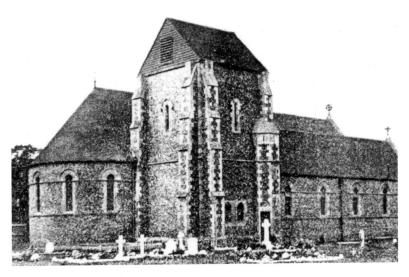

The new church was built in 1873.

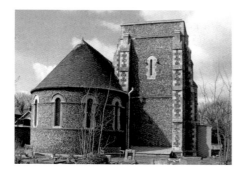

View from the east.

The church now has five bells, presented by the *News of the World* newspaper. They were dedicated by the assistant Bishop of Canterbury, the Rt. Revd K. C. Warner. M. A. on 25 March 1965.

Originally, it had the Oldfield bell from the old church and also a bell of 7 cwt from a Leysdown church, which was cast by the Whitechapel bell foundry in 1673.

Parts of the old church were incorporated into the new church. The three pillars, supporting the arches separating the north aisle or arcade from the Nave, have parts of two of the circular piers and capitals from the old church, which can be seen as lighter parts of the columns and capitals. The panelling between the arches was a later edition, erected in 1989 with money bequeathed to the church by Grace Sorrell. This part of the church is now called the Grace Sorrell Room.

The Brass of John Eveas was taken from the old church and re-sited in the floor of the church, under the carpet in front of the pulpit.

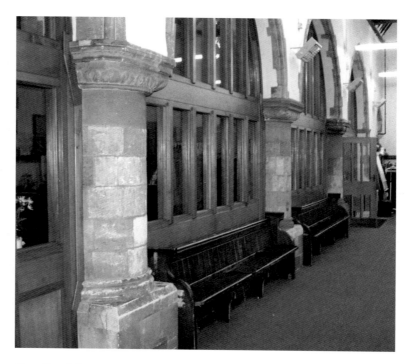

Grace Sorrell Room.

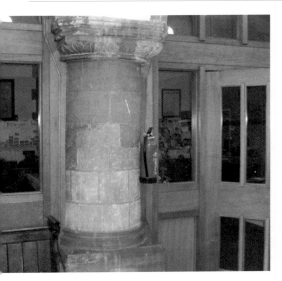

A pillar.

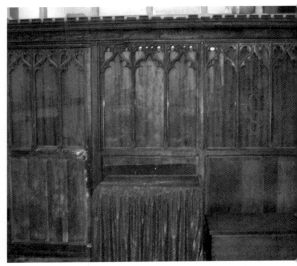

Vestry Screen.

Closer examination of the pillars shows only two columns from the old church are incorporated in supporting the three arches in the new church. The darker parts that can be seen have been fabricated to make up the three pillars.

A fifteenth-century screen from the north arcade of the old church was also used to partition off the east end of the north aisle to provide a vestry.

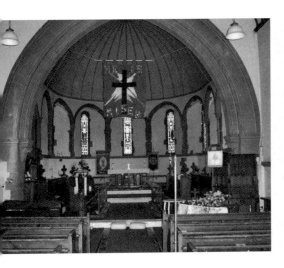

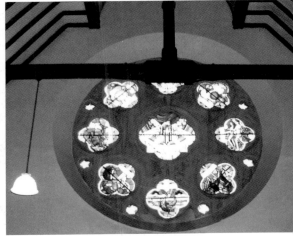

The chancel has five coloured glass lights, one erected in memory of Peers Brimlow, Organist and Choirmaster, who died 1923. The three centre lights depict the crucifixion, in memory of James Easton, Rector of Murston Parish 1897-1921. The fifth is in memory of Revd Arthur Luman, 1962-1979. A large circular or wheel window above the church door was changed to coloured glass in 1991, bought for the church by Miss Ivy Barlett who was the Organist and Choir mistress.

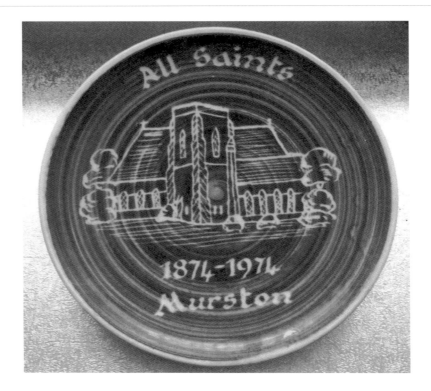

The church celebrated its centenary with five services in 1974 to mark the occasion. A commemorative plate was made at the Rainham Potteries, which was situated on land next to the Man of Kent public house on the A2 (the works closed in 1975). It is not known quite how many plates were produced, made in a blue colour with the etching showing in white. One hangs on the wall in the church near the font.

9
The Brick Industry

Hand Berths

The Kent yellow stock brick made its name in the nineteenth century, when demand for cheaper robust bricks was required for the increasing building in London. Bricks were produced in great quantities at Murston which was an ideal location, where brick earth and chalk were only yards away from the creek waterway. The first brickfield was started about 1835 by Muggleton at Adelaide Dock, a small water inlet now behind Dodd's transport yard. By 1840, McKenzie started a field between Adelaide Dock and Bayford farm, approximately where the Go Kart track is situated. Another field owned by Ashington was on the right hand side of Church Road, where the church and parish hall stand and also on the left hand side, just before Dolphin Hill.

George Smeed started his brickfield about 1846, near the old church at Lower Murston. By 1850 he had bought Murston Manor Estate, which stretched down to the river Swale and by 1865 he had acquired all the other brickfields from the main railway line down to the marshes.

His bricks had the initials SD inserted in the kick, made by the frog in the moulds. It stood for Strength and Durability, and not, as some imagined, Smeed Dean.

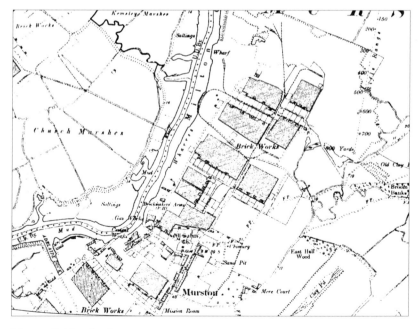

Murston Brickworks plan.

The fields, in the early days, were close to where there was brick earth, which was hand dug and made into level heaps called kerfs. Chalk was added, and ash was also screened from house refuse at so many inches to a foot of earth, which was turned and mixed throughout the winter months, ready for the brick making season which started in the spring. In later years, horse powered mixing mills were used.

It was not until 1865/75 that steam engine power was used to drive fixed wash mills and pug mills, which meant that brick making could be static in one place and the washed brick earth pumped into washbacks like slurry and allowed to settle. When firm, the chalk and ash could then be added on top, although later the chalk was washed with the brick earth.

Washbacks were large brick walled containers, with an opening called an opral nearest the pug mill in the brick making shed. There were two washbacks to each shed.

Washback ready for use.

The pug mill was like an open top drum 4ft x 3ft, with a rotating 3 inch shaft fitted with 8 knives to mix the materials. The shafts rotated at 10 rpm. These pug mills were all connected from one steam engine house by one long shaft about 300yds in length, mounted on brick piers, connecting each hand berth pug mill. Some pug mills were at right angles to the main shaft and were connected via bevel gears.

Each hand berth had a gang of six, which included the temperer, who loaded the pug and ash from the washback on a wheel barrow, which he emptied into the pug mill, and a flatty, who cut the wad of pug from an opening at the front of the pug mill and rolled it ready for the brick moulder to throw into the mould (which was in two parts). The mould was then lifted from the stock, which held the kick, or frog, and turned onto a board on a narrow frame called a page, which was at right angles to the moulding table. The board (approx. 11in x 5in) and brick was then placed on the off bearing barrow, by the barrow loader. When loaded, a pushy out would wheel the barrow into the drying ground, where the off bearer set the bricks onto long boards, supported on blocks 4in off the ground. When dried firm enough to handle, the bricks would be turned in alternate diagonal rows, (skintled) with gaps between each brick to allow air to pass through.

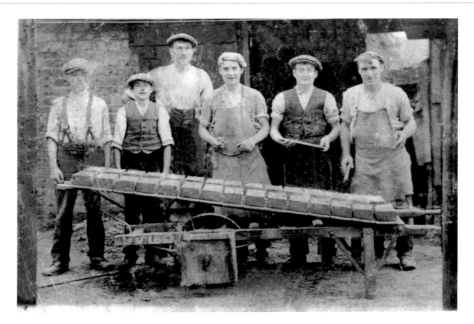

Hand berth brick making gang.

The chap on the right of the above photograph is moulder brick maker Bert Spice, called Sapper. The tall chap third from left is Harry Woollett; he was known as Tarpot. I knew both of these men who lived in Murston. The other men I do not know.

The double row of bricks on the right of the picture below left, five high, have not been skintled, and the other rows to the left have been stacked in alternate rows of diagonal bricks (skintled), to allow for better drying. Between the rows of unskintled bricks, there are wooden caps which were put over the bricks if it looked like raining. In later years, permanent wooden structures were built over the drying grounds. These were called hacks.

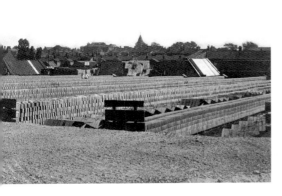

Drying bricks.

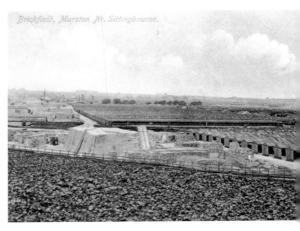

Drying hacks.

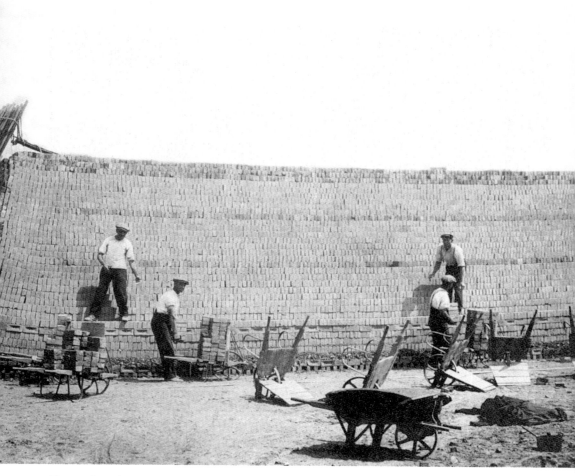

Clamp Kiln in the process of being built.

Once dried, the bricks would be taken to the kiln ground by crowders on one wheel crowding barrows holding seventy to eighty bricks. They were then built into firing clamps to be burnt.

The moulder setters were in charge of building and firing the clamps. Then, once the clamps were burnt, the bricks were sorted in to their various grades.

Brick making in the days of the hand berths was seasonal from April to October, depending on weather conditions. Only the skilled workers were kept on during winter months, working on unloading barges and screening the household refuse, also firing and tending the clamps. The rest of the gangs were laid off until the new season started. These men and their families were given some financial support by the village parish. This was termed as going on the parish. It was only when mechanisation and brick driers were installed in the fields that brick making became an all year occupation.

Monarch Machine Berths

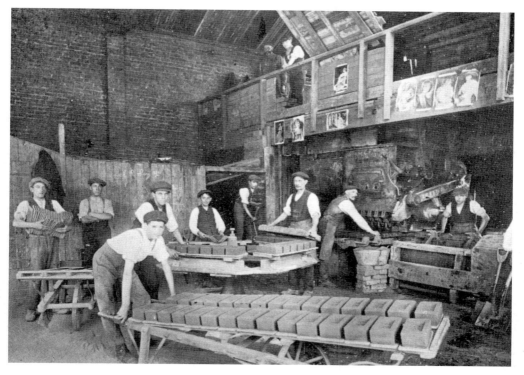

Red's Machine.

This machine was known as the 'Red's' situated below Orchard Cottages and the Golden Ball public house, in what is now the EuroLink Industrial site. The drying hacks and machine shed would have been on the northern side of what is now Johnson's factory, at the bottom of Dolphin Hill.

There was also another plant called the 'Pragos' in front of Adelaide dock, about where Able Glass factory is in EuroLink.

These machines made around 2,000 bricks per hour, approximately 16,000 in an 8 hour day, and there was always rivalry between the two sheds, which employed about a dozen men and boys. Both of these machine plants closed in 1963.

The gangs of twelve consisted of a miller to mill the materials, a mould/washer who also cleared pug that was struck off the moulds, a mould sander who fed moulds to the machine, and a board spreader who spread six boards onto a hexagonal rotating table, and turned for the two brick makers to upend the moulds carrying six bricks onto the boards.

The barrow loader, who using two sticks, took three bricks at a time and placed them onto the hack barrow, which, when loaded with thirty bricks, the pushy out would push the barrows into the drying hacks, where the off bearers would unload the bricks onto long boards, running the entire length of the hack. The bricks would be stood on their side to dry. This was called grounding out (the first bricks on the boards); once the process of grounding out is completed over the entire hacking ground, bricks are then set on top of these up to seven rows high. When dry enough to handle, they would then be reset, and turned 45 degrees with spaces between, in alternate rows on top of

one another to allow air through the bricks. This is known as skintling. Once the bricks are dry of moisture, they are then collected by men called crowders, who in turn load their one wheel barrows with approximately seventy-eight bricks, and take them to the Hoffman burning kilns. They set them in such a way for the fire to travel through, and with feed holes for coal to help burn the bricks, these kilns have sixteen chambers, in two rows of eight back to back. Once burnt, they are sorted into their various grades by sorters. Before the Hoffman burning kilns, bricks were set into clamps and fired by faggots and breeze, (breeze being the larger residual ash) that was sifted from the Victorian rubbish, brought back from London, by barges returning from delivering bricks to the Capital.

These monarch berths became all year round production. After the summer season March to October had finished, the off bearers worked in the machine shed, setting bricks from the hexagonal tables on their side on metal pallets, which were loaded on to the drier cars. The lads that were the pushy outs and barrow loaders had these jobs in the winter time, so no one was stood off. The drier cars at the Red's monarch berth were iron frames on four wheels, a total of eighteen shelves were in two sections of nine shelves. Three pallets with nine bricks on each were loaded on each shelf. Once the cars were loaded, they were transported by a transfer bogie in to long static brick built driers to be dried by hot air. There were six tracks through the drier, as six cars were pushed in, another six came out at the other end of the drier with dried bricks, ready for the crowder/setters to unload and transport by barrow to the kiln.

The Pragos plant had a different arrangement of transporting bricks to the driers, which was single chambers, eighteen in all. The cars had a lever system that picked up the loaded pallets from lifts near the machine, (like a forklift) then pulled onto a transfer bogie that had a turn table. It was then pushed to the driers. The rails of the bogie were aligned with the drier rails so the forked car of bricks could transfer the loaded pallets onto shelves, built into the drier walls. Once empty, the car was then used to fetch dry bricks from a finished drier and once returned to the bogie, turned on the turntable; the loaded dry bricks were then unloaded on pallets onto stands, for crowder/setters to unload onto barrows to take to the kilns. The forked cars were then picked up from empty pallets from another stand and taken by the transfer bogie back to the lifts at the machine, to be reloaded. There were only three forked cars and two transfer bogies on this system. The transfer bogies ran on two parallel tracks. Each had a platform with rails to allow the forked car to traverse over the other bogie track, when loading stands and collecting empty pallets from the stands. It had to be lifted while traversing to and from the driers, so that the other transfer bogie could go past.

The Red's Monarch was installed 1906. The Pragos Monarch was installed 1928.

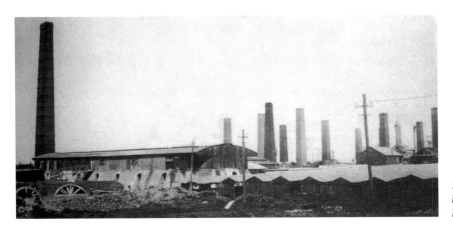

Red's Brick kiln and drying hacks.

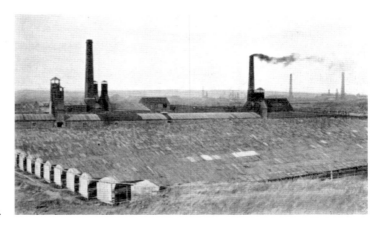

Upper Field Works.

There were two other Monarch berths in the upper field, which were situated in what is now EuroLink. They were in the lower ground opposite Murston Infant School and the church. There were also hacks and old hand berths on the left side of the old brickfield road, which ran from West Lane railway arch.

The upper field began from the railway siding, up past the old sewer pumping works (now Calor Gas); and through to what is now Dolphin Hill. These fields closed at the outbreak of the Second World War in 1939, but one machine ran for one summer season during 1950. Although the drier and kiln could not be used, bricks were dried in the hacks and burnt in a clamp kiln on the cale ground. Harry Woollett (Tarpot) was the last person to fire this clamp. The upper field Monarch's was installed between 1911 and 1921. The lower, middle and upper fields, although connected by roads, were also connected by a two foot gauge railway. This ran from the railway siding in the upper field along the dirt road through the field, passing the works main office (Dolphin Hill). It continued through the orchard behind Orchard Cottages, crossing Stable Road just below the now Woodcombe club. It then ran down White Road emerging between the blocks of houses in Gas Road, crossing the road and going behind the old church between the washbacks of the hand berths to the lower field. It then carried on to the Marsh berth. The small loco pulled Jubilee trucks supplying coal to the old steam engine houses which ran the hand berths.

Auto Brick Plant

Around the south east of England the sub soil in the fields is mainly brown earth, suitable for making bricks. There is also an abundance of chalk, another ingredient for making yellow bricks, but to make the Kent yellow brick known as London stocks, there was a further ingredient called town ash, commonly called soil breeze. This came from recycled Victorian household rubbish from London, brought by barge in the 1800s. This was screened to get the ash from it and what remained was then stored in vast heaps to decompose.

Firstly the fields are trial dug, i.e. holes to find the depth of the mineral earth (brick earth), which in general ranges from 1 to 3 metres in depth. This is normally the best earth. Below this it is generally chalky and stony, or sometimes gravel which is no good for brick making.

Once the field has been marked out, the digging or so called winning the brick earth can begin during the summer months. The top soil has to be removed and stored, ready to be replaced after the brick earth sub soil is removed. This allows the owners of the land, normally farmers, to reuse

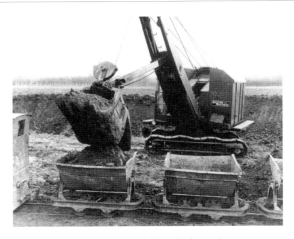

Digging brick earth from the field ready for washing.

the field which causes the least disruption to his business; although he gets paid for crops and time lost which is set in the price paid for the minerals. The brick earth is dug by a mechanical face shovel and transported in trucks to the washmill by a small loco.

The brick earth is then washed into slurry, ready to be pumped to the washbacks at the brickworks, chalk slurry being added from a separate washmill which can be a considerable distance away.

Once the brick earth has settled and the surface water drained, it is allowed to dry into a manageable form of clay which normally takes a year to eighteen months. There are a number of washbacks at the Auto plant to allow continuous brick making all year round, although washing only takes place during the summer months.

When ready for making bricks, the washbacks are opened and the clay, called pug, is dug by another mechanical face shovel, loading it into Jubilee trucks which already have the required amount of soil (ash) in; this is then transported to the mixing mill (pug mill) by a small two foot gauge loco.

Brick earth washmill.

Washed brick earth slurry in washback.

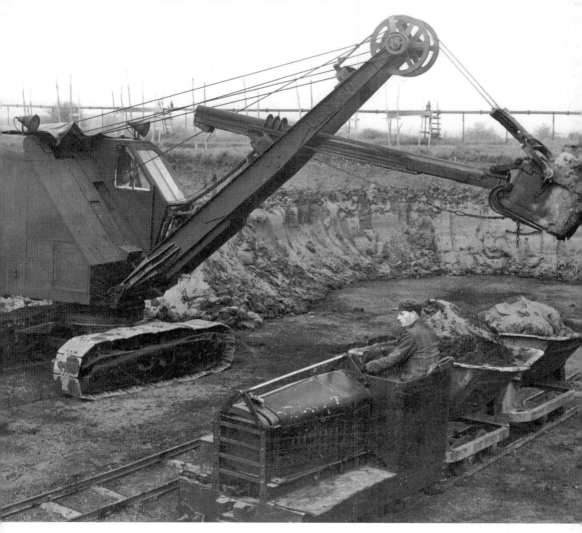

Loading pug in washback.

The Osgood face shovel driver was Frank Austin, the loco driver was Doug Flower. I took over driving the loco from Doug in 1960. Later, Frank drove a new Ruston RB10, which was replaced when the washed earth or pug was dug and transported by mechanical Murhill shovel, tipping directly into the pug mill. Soil was also tipped into the mill by a small mechanical Murhill shovel.

Originally soil was fed into the pug mill via a conveyor belt, over which was a magnet to extract metal objects. The hopper's and conveyor system was disused in the 1940s and soil was then loaded into the Jubilee Trucks by hand.

The materials were then mixed by rotating knives and paddles which were set at an angle on a shaft, to allow the mixture to traverse through the mill and drop onto a conveyor belt. This carried the mixture commonly called pug, to the brick machine.

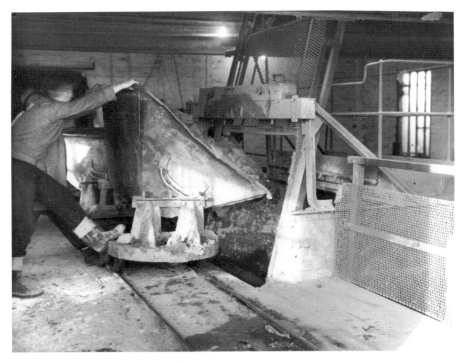

Trucks being emptied into the pug mill.

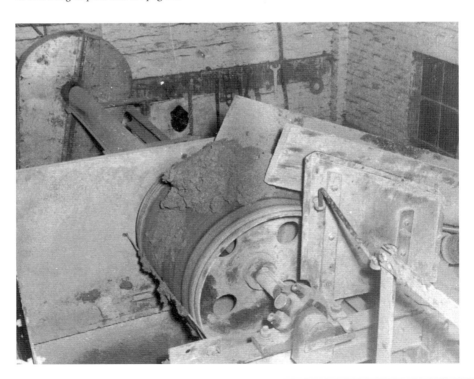

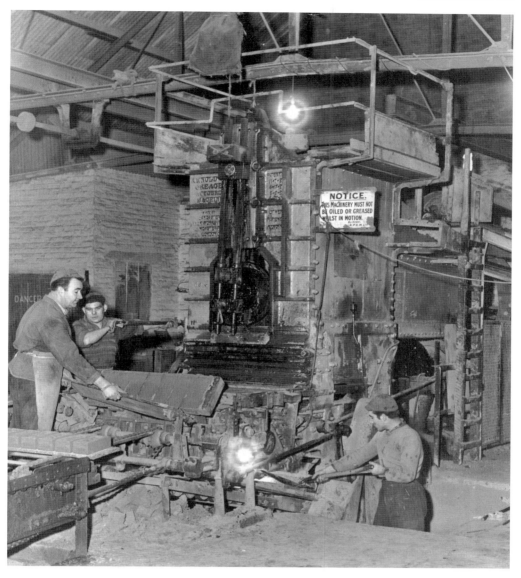

Lancaster brick machine.

The automated American brick machine, called a Lancaster, was installed at the Auto plant Lower Murston when it was built in 1928.

This machine was capable of 10,000 bricks per hour. The pug was fed under the press by a rotating sweep, and then pressed into moulds that held 7 bricks. The bricks were transferred onto steel pallets fed onto the machine by two operatives. The moulds then returned via rollers to a sand drum which, once sanded, was fed back in turn to the machine. I cannot remember the sander operator's name, but later Dennis Austin did this job.

The machine operators were Jack Beard, foremost on the left and Sid Lacey next to him, with his hands on the machine clutch starting handle.

Once the bricks were demoulded onto the pallets by the demoulding dump gear, they were transferred by chain to shelves on drier cars. These were iron frames on four wheels fed onto a lift in front of the machine.

There were six tracks through the drier, but before entering the main drier the loaded cars traversed through a semi drier, which had three tracks through one side and three tracks back on the other side. Originally all the driers were heated by steam flowing through pipes, circulated by fans built in the side wall and run by a system of belt drives from an electric motor. The old coal fired steam boiler was eventually replaced and the main drier was changed to hot air drying from an oil burner.

When the loaded cars had traversed round the semi drier, they were transferred by a transfer bogie onto the six tracks in front of the main drier ready for pushing. When the six cars were fed into the drier and pushing began by belt driven rams, six cars exited from the other end fully dried. These

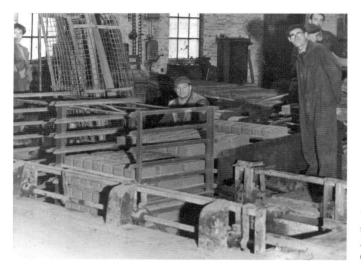

The lift operator was Jim West, with John Blake (Tojo) looking on. Extreme left of picture is Lenny Gibbs, mould washer.

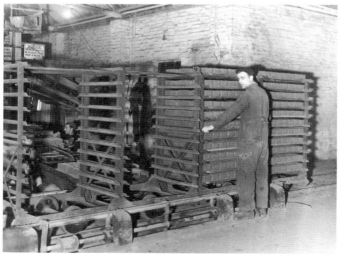

Loaded car taken to drier. Machine operator is Brian Epps.

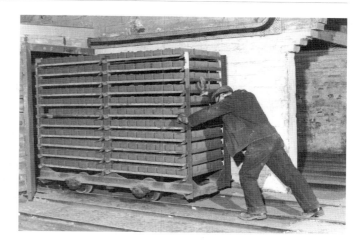

Drier Attendant Charlie Watson pushing a loaded car into the main drier.

were then transferred by transfer bogie to the lifts and sent up to the setting floor. There were two lifts, as one took full cars of bricks up, and the other brought empty cars down.

There were three exit drier attendants who manned this area, not only supplying the setting floor with loaded cars, but also pushing all the empty cars down return tracks for reloading in the brick machine shed. They also traversed the cars round on the tracks in the semi drier.

Once the bricks were on the setting floor there were setters working shifts loading the kiln cars, setting the bricks in such ways to align the bricks on the cars, with coal feeding holes in the kiln and flue holes for the kiln fans to draw the fire.

The kiln was a continuous burning kiln about 500 feet in length. It held 60 cars and each car held about 5,000 bricks and, depending on the amount of bricks made, determined how many kiln cars set could be pushed through the kiln daily. It would have been approximately six or eight every twenty-four hours. The kiln was fired by coal (known as singles) through holes in the tunnel kiln roof on to the cars to assist ignition of the fuel ash in the bricks.

The kiln burner operator was responsible for regulating the amount of coal required, until temperatures in the firing zone reaching 1,000 plus degrees centigrade. This would ignite the bricks, after which coal would be reduced or stopped.

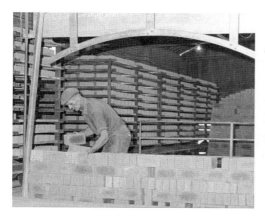

Henry Hughes setting the kiln car.

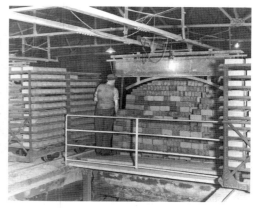

Kiln car showing building frame size.

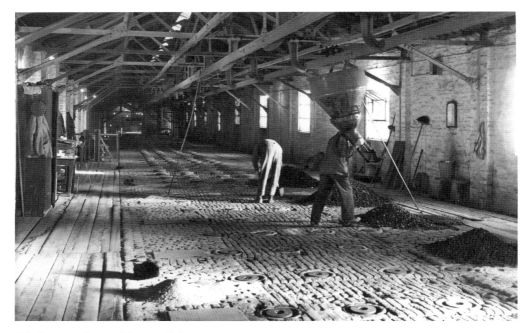

Kiln floor over the top of the tunnel kiln.

The cars ran on rails on a decline through the kiln. When a loaded car was pushed into the kiln by a geared ram, another exited from the other end. There were always metal skid shoes placed under the wheels of the third from the end car after each push. This stopped the cars all running out, causing a catastrophe.

A warning alarm was sounded, one blast to open kiln doors, another blast when pushing commenced, when the ram attendant was ready to start the push. A final blast sounded when the ram had finished pushing. This in turn warned the burner attendant at the exit end.

The finished burnt bricks on the kiln cars were then transferred to an outside storage track where they would carry on cooling.

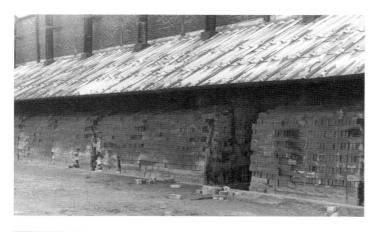

Storage track.

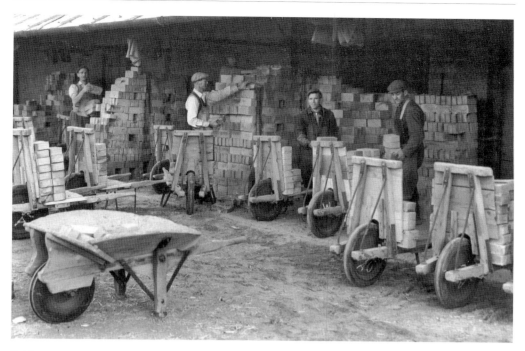

Brick sorters.

From here sorters would then unload the cars and sort them into the various grades, then wheel their loaded barrows out onto the stacking ground. I had seen their barrows burning in the past with bricks that were still red hot.

The picture below shows fuel ash being screened by modern machinery, first used during the 1960s, when it was decided to recycle the old Victorian refuse.

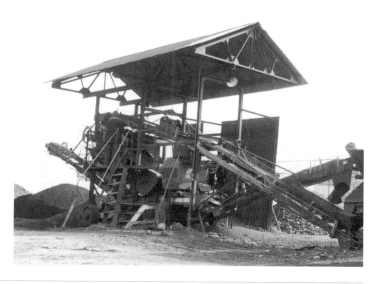

Parker screen with crusher.

Items found in recycled ash.

The road to the Auto plant was from the old church at Murston, past the detached house of the Gasworks Manager and the two villas for Smeed Dean's foremen.

Passing by what remains of the old washbacks and where the hacks were on the left, next to the sand pit of the old hand berths.

This was a favourite area where the children of Murston use to play. Pictured (*below right*) from left to right, kneeling, are Sandra Ward, Maureen Phipps, and Brenda Field. Sitting down are Vanda Port and Mick Brown.

The road (*pictured opposite top*) then carried on through what was once the old brickfields and then turned left to the Auto plant.

Passing the Auto plant new offices built during the late 1970s.

This is the main works yard. The large buildings in the background are the machine shed and driers of the new plant.

There was also another works dirt road that led to the Auto plant along the creek side from the cement works, past the rear of the old disused gasworks and the Brickmakers Arms pub. It passed an old building on the site of the old Chemical works which closed in the 1890s, to the Auto plant old office and fitting shop at the end of the main Auto Road. The office was used as a burner's hut when the works changed over to Clamp burning during the 1980s.

The old road then led to the brickworks wharf at the creek, where bricks were loaded onto barges in years gone by. This was also where sand for brickmaking was unloaded, before being transported by road. There were also old concrete buildings with grids at the top, used for screening the old Victorian refuse brought back from London by returning barges. These were unloaded by steam cranes. The road then carried on to the marsh berth where most of the refuse was unloaded and screened, right up until the late 1940s.

The larger unscreened material was then taken by trucks pulled by a narrow gauge loco and dumped in large heaps. This is now being reclaimed and screened today for firing in the Kent Stock Brick, still being made at the Auto plant.

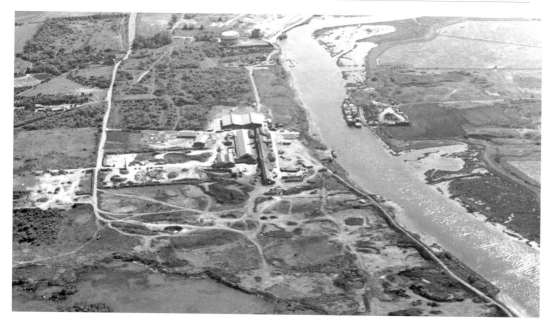

This is a view of the Auto plant lower field in 1980.

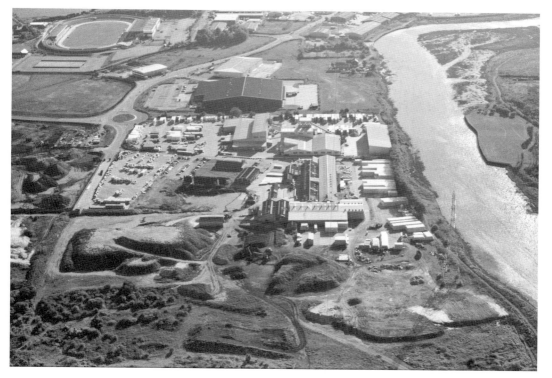

The same view in 2001, with Central Park at the top left.

Auto Brick Plant

At the Auto plant in Murston, the brick making process changed from washed brick earth to a semi dry system in 1975. This process is still in use today. Brick earth is transported to the works by lorry and stockpiled in large heaps. This is allowed to weather before use and usually there is enough weathered stock for production to be continuous all year.

Chalk is also stocked but in small quantities under cover, in order to keep it dry. Although town ash is still used as firing, coal breeze is now added to help increase the calorific value (BthU) to about 4,000/5,000.

Stock piles and feeding hoppers.

I took over driving the mechanical shovel in 1979, loading the hoppers and making the stock piles after the lorries had emptied the transported brick earth.

In the foreground is part of the brick earth stock pile behind which is the chalk and sand storage building. Coal breeze is stored at the side. The hoppers in the background feed brick earth, chalk and soil.

The vast quantities of London refuse left to decompose had broken down into soil and, because the ash from Battersea power station ceased, the cost of buying in material for firing became expensive. It was decided to try and reclaim these large quantities of soil, during the 1960s.

It was found that the ash varied in calorific value owing to some being burnt. The dark soil was retained for brick making; the burnt red ash was sold and purchased by a contractor.

I worked on the first Parker screen during the 1970s, finding many objects as the soil was being screened, but then in 1979 I changed to operating the brick earth mechanical shovel.

Employees who dug the brick earth during the summer months dug and brought the soil up in the winter.

As the old screen was badly in need of repair a new type of power screen was bought for screening soil.

A new Power Screen. Ash being screened during months when brick earth is not being dug.

The different processing equipment installed in 1975, feeds the raw materials in a dry condition, water not being added until they reach a mixing mill. The hoppers are loaded by mechanical shovel which feeds brick earth, chalk and town ash on to a conveyor belt which transports them to the mixing mill.

Coal breeze is fed by a special hopper which measures out the correct amount to be added.

The other hoppers have doors on their front which can be wound up or down to control the feed rate. Chalk and coal breeze is only 13% and town ash about 25% of the mixture, although this can be varied to suit the type of brick being made.

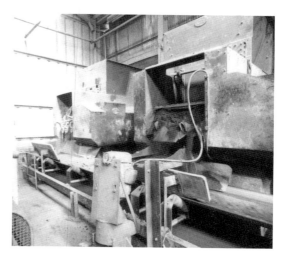

Hoppers feeding the conveyor belt.

Water is added at the first mixing mill and from here it is fed by conveyor to a pan mill, which has rotating heavy wheels that further crush the mixture and push it through slotted steel grids.

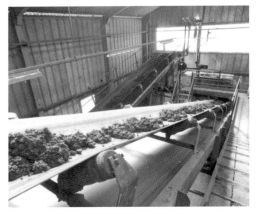

From the first mixing mill.

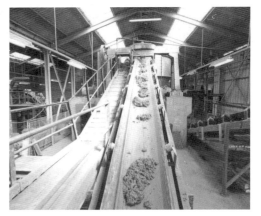

To the pan mill.

pan mill wheels.

From the pan mill it then travels by conveyor to a pair of high speed rolls which further crushes the mixture.

From the high speed rolls to the final mixing mill, the mixture commonly called pug goes by slatted conveyor to the automatic brick making machine.

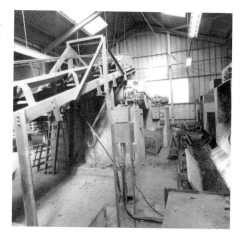

Right: *High speed rolls.*
Below: *Final mixing mill.*

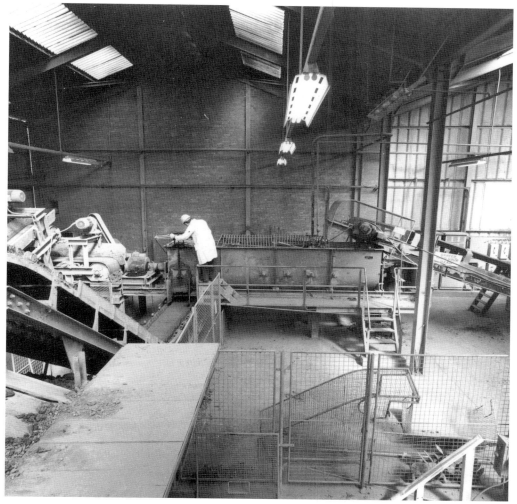

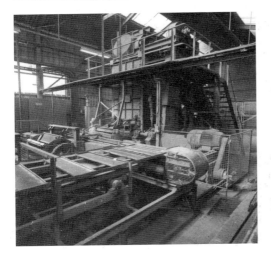

Aberson brick machine.

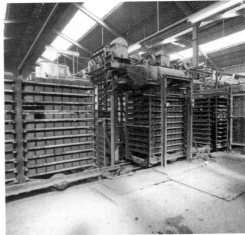

Loaded drier cars are transferred by cable to drier.

A new type of Dutch brick machine, called Aberson, was installed in 1975, capable of making 12,000 bricks per hour. The bricks from this machine are demoulded onto steel pallets, which were then fed on to a hoist and hydraulically pushed on to awaiting drier cars.

The building which housed the driers was extended to allow fork lift trucks to lift the drier cars up and transport them out to the new clamp sheds, built in 1979, returning with the empty cars to put on a return track back to the machine.

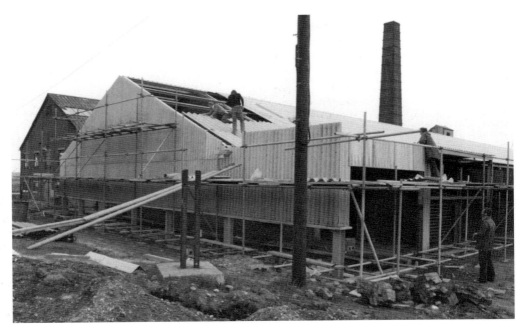

Drier extension.

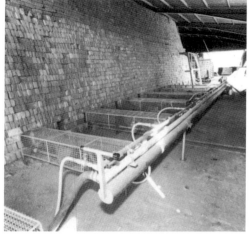

Fork lift truck picking up car in drier extension.

Gas burner probes.

The old tunnel kiln was replaced by two clamp sheds having a capacity to hold 1.5 million bricks; these were fired by Natural Gas.

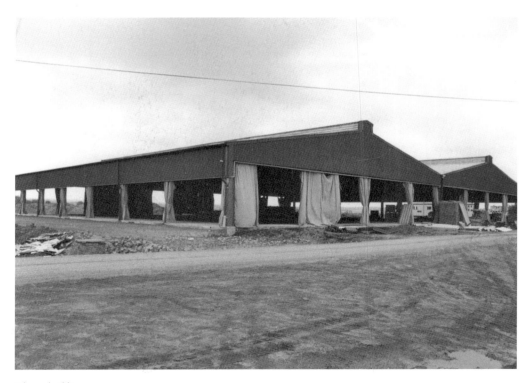

Clamp buildings.

During the 1980s many modifications were made in drying the bricks. Using hot air from gas burners installed above a newly built drier, the air is circulated through the bricks in double drier chambers that are sealed when full. It takes forty-eight to sixty hours to dry the bricks.

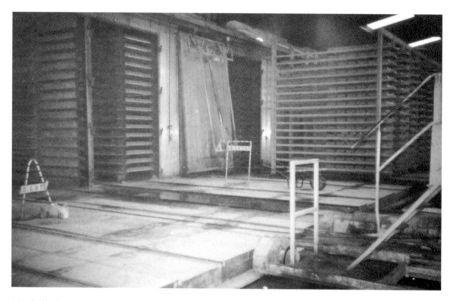

Newly built modern drier.

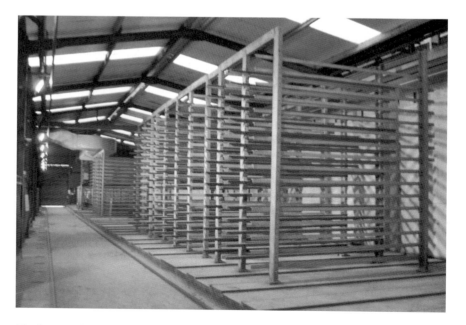

The frames in front of the drier.

Two hoists, called gathering frames, were installed. One is fed from the Arberson brick machine with palleted wet made bricks on to shelves. The loaded pallets are taken off by a transporter, called a finger car, which takes the bricks to the driers. It releases the pallets on to permanent frames in the individual driers and then collects pallets of dried bricks from other chambers, and takes them back to the other gathering frame for depalletising. The empty pallets are then fed back to the brick machine for reloading with bricks.

Dry bricks being depalletised.

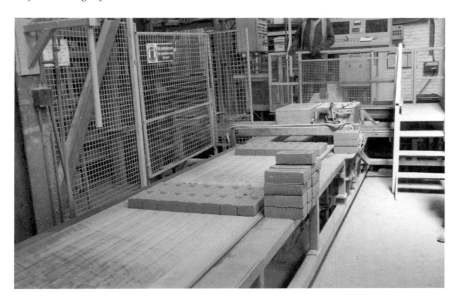

For a time the bricks were manhandled, stacked on wooden pallets and transported to the clamp kiln sheds. This was until a new tunnel kiln was commissioned in 1989.

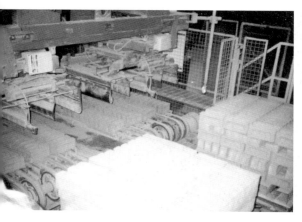

Cubing machine.

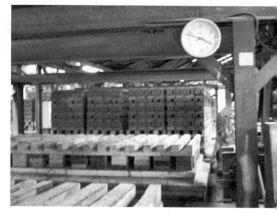

Setting machine.

Once the new kiln was commissioned, bricks were then fed to a cubing machine where dry bricks are assembled into cubes of 480 bricks, ready to be loaded automatically onto kiln cars by a setting machine, for burning in the new tunnel kiln.

There are 8 cubes per kiln car, which equates to 3,840 bricks per car.

The loaded kiln cars are then fed automatically into a tunnel kiln to burn. The kiln is continuous burning over a period of twenty-four hours, seven days a week. Bricks first enter a pre-heat zone, taking out any moisture, then move to a firing zone. This has natural gas burners to fire and ignite the ash and breeze content inside the bricks, which carry on burning after they leave the firing zone.

The cars are pushed through the kiln by a hydraulic ram. As one car enters, one car is pushed into the exit vestibule ready to be taken out. The kiln is 110 metres long and holds fifty cars, plus two more in the entrance and exit vestibules.

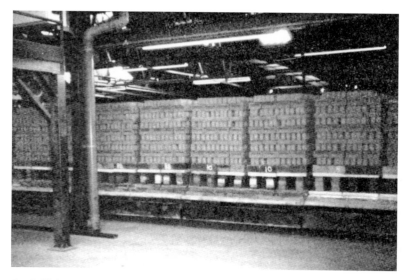

Loaded kiln cars ready for burning.

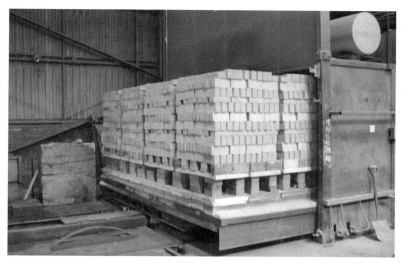

Car exiting kiln.

Although still hot, the cars are transferred onto a kiln return track where fork lift trucks unload the burnt bricks to a sorting bay, for men to sort and grade the bricks. The kiln cars are then repaired ready to be reloaded with green dried bricks for burning.

The burnt graded bricks are stacked on wooden pallets in their various grades and shrink wrapped. They are then taken to the stock yard by fork lift truck, awaiting orders for sale.

Sorting and grading is the only manual handling done in the whole process, apart from where cracked or damage bricks are replaced during production.

Ownership of the plant changed from Blue Circle (formerly APCM) to Chelwood Brick in 1997. They merged with Ambion Brick in 2002 to form The Brick Business. This was sold to an Austrian company named Wienerberger in 2004. The plant has had various names, from Blue Circle Enterprises to Ockley Brick, but is now called The Smeed Dean Works.

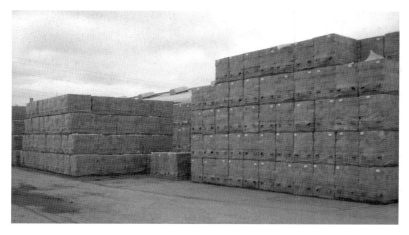

Bricks in stack yard.

Drag line.

Modern digging machines used in loading the brick earth also changed with the times. Face shovels cut up through the earth, while drag lines drag up through it.

Now a modern 360 degree machine cuts up through the face more efficiently (*below*).

10
The Cement Industry

Cement was first manufactured in Murston by the Burnham Cement Co. from 1870 until 1890, who had a small plant and two bottle kilns on land leased to them by George Smeed, near the creek next to his gasworks.

After George Hambrook Dean married Smeed's daughter Mary Ann, in 1875, both men's interests were formed into The Smeed Dean & Co. Ltd. It later merged with two other companies to become The Red Triangle Group.

By 1900 the company started producing cement in a row of chamber kilns, which were constructed of bricks from their brickfields. The chamber floor had alternate layers of coke and dried slurry, a mixture of mud and chalk, built upon it, under which was a firing tunnel where faggots were used for firing. After the chambers had been fired and cooled down, the cement clinker was raked out from underneath the grids to be ground into powder in the stone mill and finished into granules in the three brush mills.

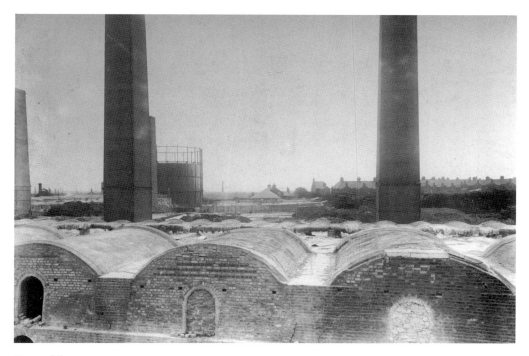

Cement kilns.

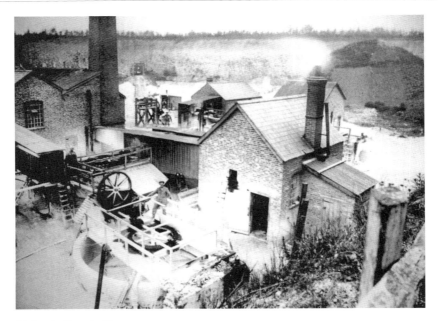

Highsted old washmill.

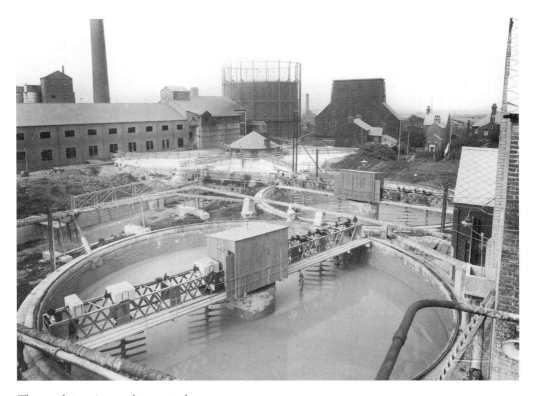

The new slurry mixers and storage tanks.

Mud for cement was first dug from the River Swale at Elmley. Gangs of men, called muddies, loaded barges using a tool shaped like a rowing oar called a fly tool. The barges transported the mud to the work's washmill.

Chalk was now being dug manually from the old Highsted pit, opened in the 1890s on the eastern side of the Highsted Road. The loaded trucks were hauled by a small narrow gauge loco to a washmill powered by steam.

The washed chalk slurry was then pumped via a 6 inch pipeline from the quarry to storage backs at the works in Murston; a 5 inch pipeline was also laid to supply the brickfield's washmill in Happy Valley, now the site of Gorse Road below Sunny Bank.

Between 1925 and 1928 two new Smidth Rotary Kilns were installed at Murston, each 226 feet long and approximately 9 feet in diameter. These were steel tubes rotating at an angle for the slurry to descend into a firing zone lined with bricks, from where it emerged as cement clinker.

Also installed were two wet grinding mills, a mill with clinker and gypsum hoppers and cement storing silos. As well as a packing plant there was also a coal drier and grinding mill. All the new plant was built inside brand new buildings.

A coal handling plant was built for supplying the kilns and power house, which housed a complete turbine power plant of 2000 Kilowatt capacity with water tube boilers, needed to power the new machinery. The power plant, however, was discontinued when electrical supply from the National Grid was installed in 1945/6.

In 1931 when the APCM (Associated Portland Cement Manufacturers) took over the works, a new finishing washmill was installed to improve the mixture of clay and chalk. There were also two new round slurry mixers and storage tanks which finally mix the slurry, before being pumped into the rotary kilns. These were fired by pulverised coal blown into the kilns at high pressure.

The rotary kiln building can be seen in the background, extending from the coal handling plant building. To the right of the gas storage holder is the wooden water cooler structure which cooled water from the steam turbines.

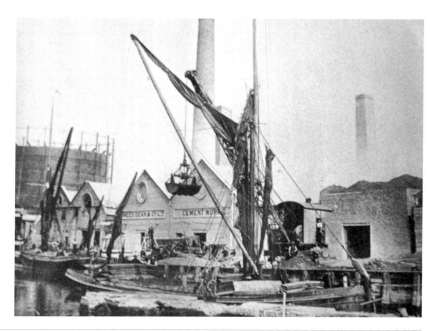

Old cement works.

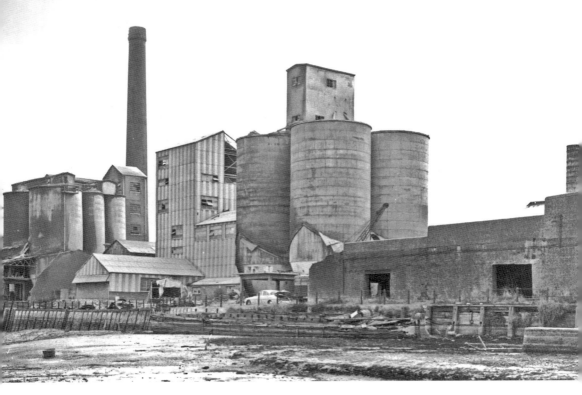

Modern cement works.

Clay by now was being dug around the Broom Banks area. As the clay was dug the holes filled with water, leaving large lakes, many of which can still be seen. The three that belong to the Sittingbourne angling club are some of these workings. The last one of the three was exhausted in about 1950.

Clay was excavated by a mechanical dredging machine with an endless chain of buckets, which emptied the mud into trucks under a hopper; previous to this a type of steam dredger was used.

The loaded trucks were hauled to the cement washmill at Murston works by a steam loco on a railroad known as the Broom Banks railway. It crossed fields and farmland behind Meres Court farm towards East Hall, turning up along the farm road which was next to Murston Recreation ground and crossing Church Road at the stables (now Woodcombe Club). It then went round behind the houses in Church Road and on to the washmill.

When the loco reached Church Road going in either direction, the driver's mate had to stand in the middle of the road with a flag in daylight hours, and with a red warning lantern after dark, to warn motorists that the train was about to cross. There were also 'Beware of the Train' warning signs at each side of the crossing.

From about 1950 the railroad was extended to the marshes at Elmley, where new workings were taking place. The old steam loco was replaced by a diesel Hibberd loco and the trucks were loaded by a drag line.

When the houses in Gas Road, Lower Murston and the old brickfields from behind the old church were cleared after 1965, the railroad was re-routed behind the church, eventually crossing the

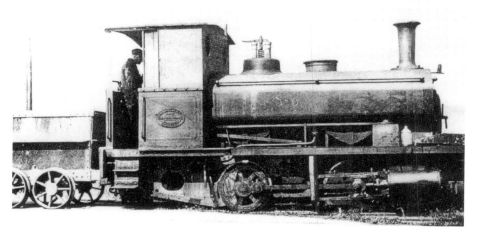

Broom Banks loco.

old Auto plant road, all of which is now part of the extended industrial site. This connected up to the marsh section of rails at Trimtram, behind the old sewage works, now the gypsy camp site.

The railroad lasted a further five years and ceased working in 1970 when the cement works closed. The rail network was sold as scrap.

Remnants of the old Broom Banks railway can still be seen in the road along the side of Woodcombe Club house, in what was the old stables road that led down past the Reds and Pragus brickworks.

As the clay was excavated from the marshes, the drag line worked its way along a drift next to the railroad. When it reached the end the rail track had to be moved so that the drag line could start another drift.

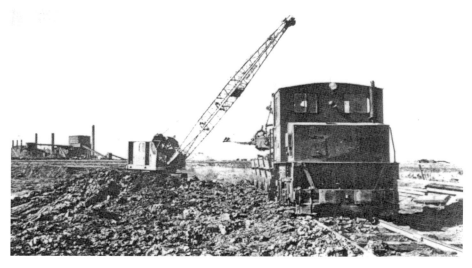

New marsh workings.

The marsh workings (*above*) can still be seen. These are now filled with water forming large lakes, one of which a Sittingbourne author had wrongly mistaken as the old Oyster Pond.

Below is an aerial view of the marsh cement mud excavations at Elmley, clearly showing the large area now filled with water. The creek and the River Swale are in the background. The little dark area at the top centre of the picture near the sea wall was the Oyster Pond.

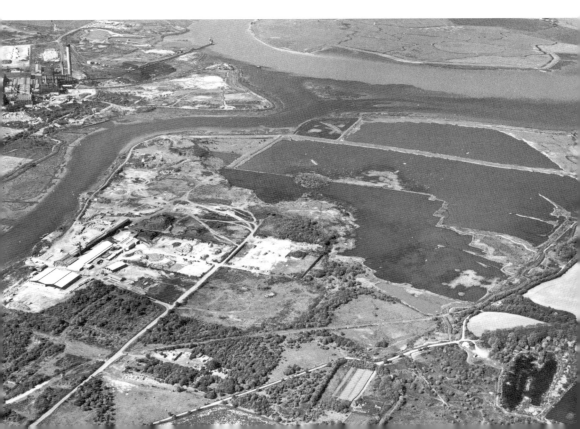

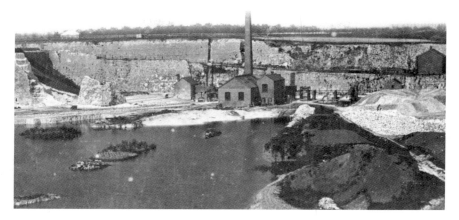

New second quarry washmill.

As the Highsted chalk quarry expanded, a new quarry was opened on the west side of Highsted Road. A tunnel was built under the road to connect the quarries. The narrow gauge railway was replaced in 1927 by a larger gauge steam loco.

In this new quarry, chalk was blasted from the pit face by explosives and steam face shovels loaded the trucks. A new washmill was eventually built in this second quarry. Although originally run by steam, it was converted to electrical power when supply from the National Grid was installed after the Second World War.

By 1949, a new diesel driven Marion navvy (face shovel) was bought to load the trucks. Later, as blasting had ceased, a Ruston Bucyrus RB32 was used on a shelf, half way up the face, throwing chalk down to the Marion navvy.

As the chalk was quarried it advanced closer to residential houses at the top of Bell Road and the decision was taken to open a new quarry on the other side of Cromer Road.

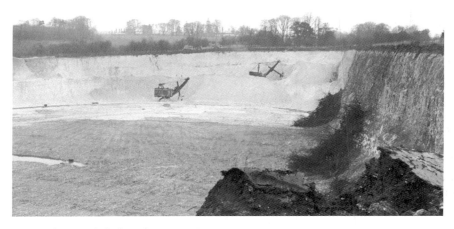

Marion throwing chalk down for Ransom Rapier.

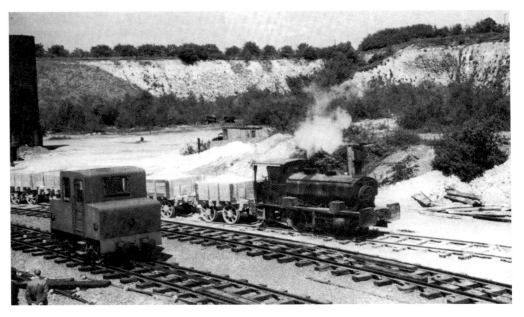

Electric loco and steam loco at Highsted.

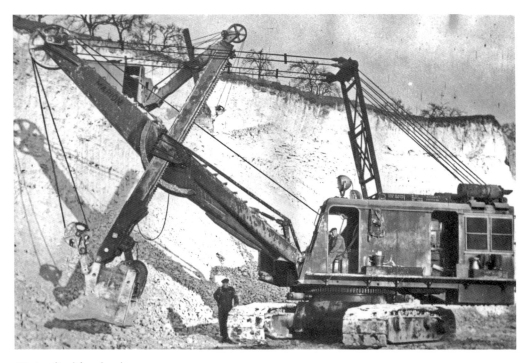

Marion diesel face shovel.

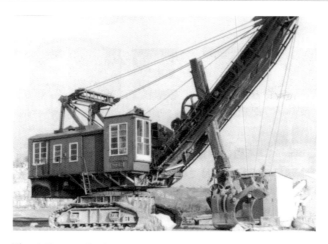

Electric Ransom Rapier 4142.

This third quarry was opened south of Cromer Road. A new tunnel was built under Cromer Road.

An electric operated Ransom Rapier 4142 navvy and a third electric rail system with electric locos were bought for use in this new quarry, taking the loaded chalk wagons back to the washmill in the second quarry.

Numerous finds have been discovered whilst quarrying at Highsted and can be seen in the Maidstone Museum, and in 1955 skeletons and pottery were unearthed dating between 75BC to 20AD.

Highsted continued supplying chalk for the auto brick plant after the cement works closed in 1970. The brick plant had been using the cement washmill from 1968 to wash its brick earth, owing to the brick earth supply pipeline, from New Garden washmill via East Hall, being destroyed by contractors when the Happy Valley Estate was being built below Sunny Bank. The cost to re-route the pipe was considered to be too expensive, resulting in the cement washmill being used for brick earth. Lorries transported the earth to the mill, which was loaded into a feed hopper by an RB19 Dragline, and fed by conveyor to the washmill.

This system ceased when the brick plant changed over to a semi dried material process in 1975.

11

In and Around Murston

The road to Lower Murston was from Snipeshill, passing down Murston Road from the Prince of Wales public house and Walker's shop, past the row of terrace houses built by Smeed Dean on the

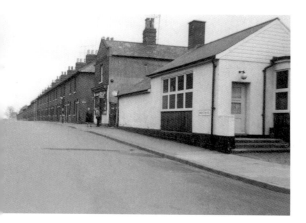

Murston Road from Snipeshill, pre-1963.

Murston Road from the New Inn, pre-1963.

right side of the road, towards the New Inn public house built in 1861.

The right-hand side has completely changed, with all new houses and flats, and with a road named Woodberry Drive from a mini roundabout.

View of Murston Road from Snipeshill, 2008.

Murston Road viewed from the New Inn, 2008.

The left side of Murston Road has barely changed, except for some new houses where Hawkins cattle yard was and flats on the corner of Thomas Road. Mrs Austin's old shop with the Brooke Bond advert over the door and a Woodbine one in the window is still there, although no longer a shop, but her daughter Eveline still lives there.

Left side of Murston Road, 2008.

Mrs Austin's old shop, 2008.

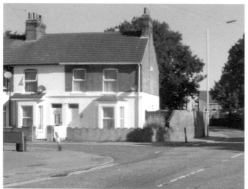

Hairdresser on the corner.

The New Inn public house.

Next to Mrs Austin's shop was Bill Mungem's hairdresser's. He always smoked Woodbine cigarettes. From here to Shortlands Road nothing seems to have changed. The shop on one side is Murston Store, now called Chris's Convenience Store, and on the other side there was a hairdresser's, originally Tommy Kennett's, but now a dwelling house since Cyril Colchin retired.

On the opposite side of Murston Road stands the New Inn public house. From research in the *East Kent Gazette*, I found the pub originally had a bowling green and the Murston Brass Band held concerts with dances on the green at the rear of the pub.

It was only when you crossed over the railway bridge from the New Inn that you were considered to be a Murstonian. There was only one footpath on the left of the bridge until a pedestrian footbridge was erected on the right side from the New Inn in 1976.

Once over the bridge, the road forks. On the left hand side is Church Road; and on the right hand side it is now a no-entry; only one way from Tonge Road. On the right of this road the Andrews family (Smeeds Managers), built the thirty-six houses in Home View and Home View Terrace. The first thirteen were built alongside the railway pre-1901; the other twenty-three were built sometime before 1908.

Home View.

Railway footbridge.

At the centre of the forked road stands the Co-op store, behind which there was a bakery, opened in 1911 and converted into flats during the 1990s. Originally the Co-op store and butcher's shop had entrances from the forked road opposite Home View, but the entrance to the store was changed to the front by the post box sometime before 1971, when a post office was installed just inside on the right.

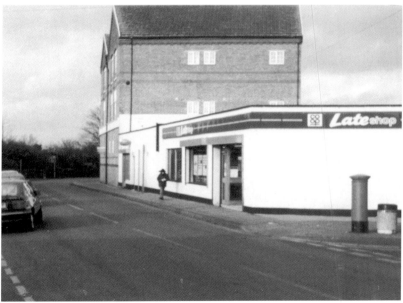

The butcher's moved to Church Road where the post office is now, but was later incorporated inside the store and the post office took over the part of the building which was formerly the butcher's shop. The butcher's finally closed and the store was re-organised with the entrance shifted to Church Road.

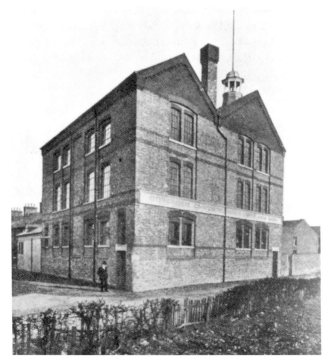

Left: *The bakehouse.*

Below: *Bakehouse converted into luxury flats.*

Next to the Co-op was the Bakehouse, which opened in 1911. Opposite the Co-op where Swan Close houses were built, there used to be a wooden building used by the scouts. I remember a large fire here when inflammable liquid stored there caught alight. I believe at the time a company named Fubex was operating in the old bakehouse. Later, a coat manufacturer named Rensor occupied the building and then it was later used as a furniture store.

On the opposite side of Church Road is Swan Close, a small group of houses.

View towards Kitneys Hill on the left.

View of Kitneys Hill before Swan Close was built.

View down Church Road and Kitneys Hill, opposite Tonge Road.

The same view in 2008.

The view opposite Tonge Road junction was Kitneys Hill.

Same view in 2008, from Tonge Road.

The road junction at the bakehouse turned right into Tonge Road. It was originally called Tracy Lane, probably after George Monk Tracy, the local surgeon, who is buried in the old Murston Church cemetery. The houses in Tonge Road were built at the turn of the century.

Above: *Home View Terrace Tonge Road, 1963.* Below: *Home View Terrace Tonge Road, 2008.*

Next to Home View Terrace is Murston House, an early Georgian building. William Mannouch lived here from 1851 to 1861. He then became the landlord of the New Inn after it was built in 1861. The Jarrett family later owned the house, yard and orchard. It has all now been built upon and the house has been converted into flats. The yard and the little shop next to the house have now gone.

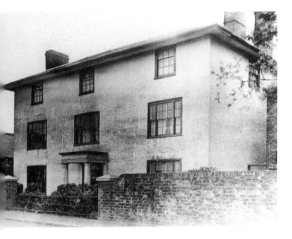

Murston House, once the home of George Monk Tracy MD.

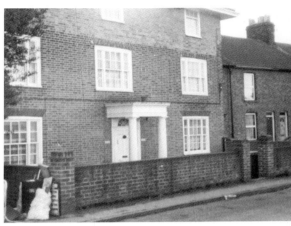

Converted into flats.

Part of Jarretts yard under repair in 1963.

Same view, now called Jarretts Court.

View of Jarretts Orchard from Tonge Road gardens.　　*Same view from the same garden.*

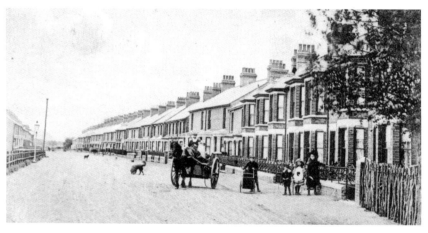

Above: *Tonge Road c. 1900s.*　Below: *Tonge Road and entrance to Wykeham Road, 2008.*

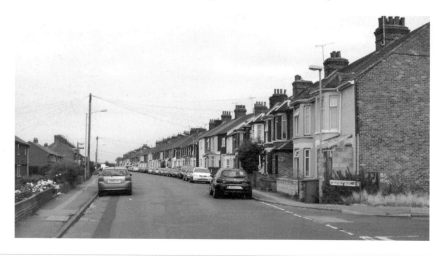

The town houses built on the old orchard site (*opposite page*) are in Wykeham Road, Smeed Close and All Saints Road.

From the electric substation opposite Murston House, the fields and allotments on the left of Tonge Road are now a housing estate, built in 1963.

View looking east from Tonge Road, 1961.

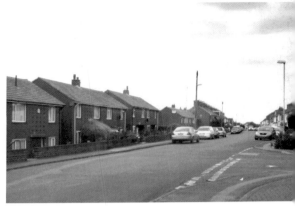

Same view, now showing new housing, 2008.

On the left of Tonge Road is Portland Avenue, the entrance to the new Murston estate built in 1963.

Entrance road, Portland Avenue.

Wells House. These flats are part of the new estate.

Churchill House residential community flats.

Originally old people's warden-controlled one room flats in Portland Avenue, until they were modified to more spacious accommodation.

Continuation of Portland Avenue leading to Broom Road.

From the eastern end of Tonge Road is Oak Road, which was originally a farm track leading to East Hall. The Smeed Dean Company built two blocks of houses here for their workers during 1914 and 1923.

Oak Road, c. 1960.

The entrance to Oak Road from Tonge Road, 1960.

The entrance to Oak Road from Tonge Road, 1995.

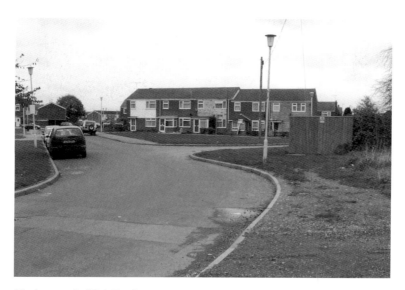

The lower end of Oak Road, 2003.

The lower end of Oak Road was once farm orchards and is now a housing estate built in the late 1960s, called Cherry Tree Estate.

This area was the site of an ancient Roman burial ground and was excavated for brick earth by the Smeed Dean Brick Company.

On the opposite side of the Co-op bakehouse on the corner of Tonge Road, stands a detached house (*below*). There used to be a large metal tank on this site for fire engine use. The metal, like many garden railings, was cut down during the war years owing to a shortage. I can remember the concrete base surround, about 20 feet in diameter, and always having about 8 inches of water in it.

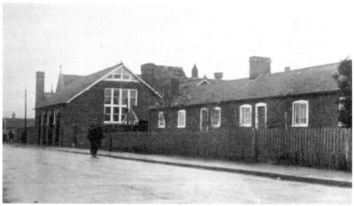

Lushington Cottages.

Next to the detached house are Ludfriars Cottages, built about 1937/8, after the old Lushington Cottages built for Ashington brickfield workers were pulled down.

Next to Ludfriar Cottages is the Murston Infant School built in 1868. This was fully detailed in earlier chapters as well as both All Saints' Churches, old and new.

Erected next to the church is a wooden building, which is now used as a nursery. It apparently was an old YMCA hut brought from Throwley airfield in 1920 for use as a Parish hall, which later became the APCM works welfare hall. When it was first erected, living accommodation was built on the side. Mr Benjamin Hawkins and his wife lived there as caretakers. He was also the church sextant and worked as a watchman with Mr Len Allen for the APCM, which later became the Blue Circle.

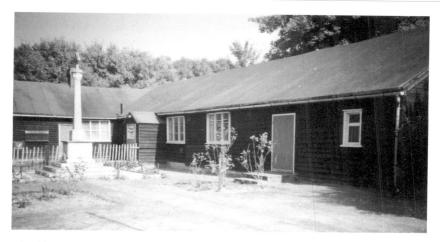

The old Parish Hall and 1914 War Memorial.

The welfare hall, as it became known, opened in 1922 and was used by the community for many functions. My parents, who were married in Murston Church, held their wedding reception in the hall like many other Murston people. I remember having to carry our school tables from the school to the hall for our school dinners, during the 1940s, as well as having our school Christmas parties and plays there.

Apparently, behind the welfare hall there were tennis courts. A slope by the side of the welfare hall led down to them. I think the slope is still visible.

The tennis courts were all overgrown and not in use in my younger days. I remember the high fencing around it though, which was at the end of the infant school hollow, now part of the junior school. I also recollect Chippy Wood and Nobby Murton keeping greyhounds near there. The opposite side of Church Road from the main railway line, which is now EuroLink Industrial Park, was the Smeed Dean Company's upper brickfields and on the left side, just below the welfare hall, there were three red houses originally built in 1848/9 for Ashington's brickfield managers. The Andrews family lived there when John Andrews came to manage Smeeds brickfields later. I recall the Wrattens, Kitneys and Stubbins living there. The houses were dismantled in 1971.

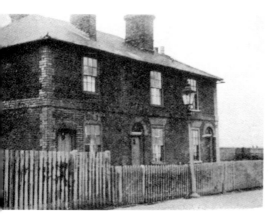
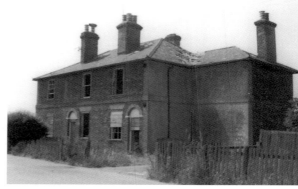

Red houses before demolition.

Further along Church Road from the welfare hall a new fence has been erected around the new junior school, built and opened in 1972.

The Sunny Bank Road leads down to the junior school.

On the other side of the road are the remains of a small disused railway arch built in 1893, where a small steam train ran under from the upper brickfield, fetching brick earth from East Hall and later Binny Hill in Tonge, to the washmill, which was situated between the end of Broom Road and Gorse Road. This was known as the East Hall railway. It ran along where Broom Road is today, crossing the orchards and fields which were once dug for brick earth.

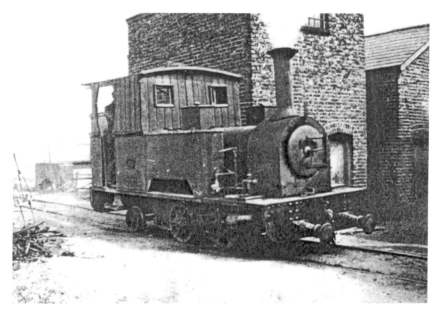

East Hall steam train and railway arch.

Railway arch at Sunny Bank re-bricked. 2005.

Next to the arch on the left side of Church Road there was a builder's yard. I remember Sid Williams working here for Bowes the builders. Later, Terry and Carr took over the yard. Both firms carried out the maintenance of Smeed Dean and later APCM's housing.

Adjoining the builder's yard was a smallholding with a large wooden building; originally this was part of Ashingtons brickfield. Tom Perry worked this land although his main occupation was in the brickfield at the Auto plant. He worked as the pug miller when I drove the loco.

At the end of the smallholding were two fine large buildings called Ebenezer Villas. These were built in 1870 for Smeed's managers. George Andrews, who wrote *Memories of Murston*, lived in one, his brother Norris in the other. I only remember Fred Hyland and Mr Gardner living in the villas. They were works foremen. I was at Murston School with Ann, Mr Gardner's daughter. The last two foremen I recollect here were Chippy Wood and Jack Cooper who were cement works foremen.

The old dirt road by the side of the villas led to the works main office and down past the Reds and Pragos brickfields to Adelaide Dock. This road is now Dolphin Hill leading into Castle Road of the EuroLink Industrial Park. It also branched to the left behind the villas large gardens, going on through the upper fields disused brickfields past the old sewer pumping works (now Swale Gas); then passing between the Co-op meadows site, now Everest Double glazing and Bayford orchards. It emerged at West Lane railway arch which was at the bottom of West Lane until the new Sittingbourne bypass, St Michael's Road, cut through.

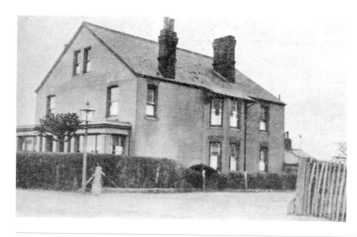

Ebenezer Villas and old dirt road to the work's office and brickfields.

Ebenezer Villa site in 1996.

On the other side of the old dirt road were Orchard Cottages. Two blocks of better built houses with bathrooms attached, built between 1923 and 1928, these were on land, originally orchards, belonging to the Golden Ball public house, which was once a farm in the days of old.

Orchard Cottages in Church Road, 1976.

Orchard Cottages, 1996.

View from where Ebenezer Villas stood, across to Dolphin Hill, with new housing adjoining Orchard Cottages.

The Golden Ball public house, on the other side of Orchard Cottages, was originally a farm house of a 10 acre farm, *c.* 1650/70. It became a beer house in the 1840s when a tap room was added. Domestic rooms were added in 1920 and a club room was built in the 1930s. I recall the landlord Jack Mantle and his wife Betty. Sid and Connie Watson took over the pub at a later date.

The Smeed Dean Company bought the orchard farm in 1890, but left an acre of ground next to the building as garden. This was eventually sold and developed for housing about 1972.

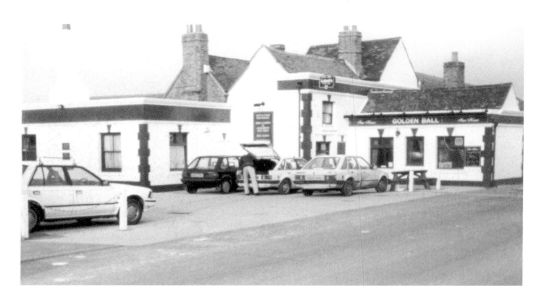

Part of the Golden Ball garden wall still visible.

On the other side of the Golden Ball orchard stood Smeed Dean Stables built in 1878, incorporating a house for the horse keeper. I can just remember two horses being in the end stalls which had iron gates, like the other stalls. The horse keeper at the time was Mr Whitehead. When I started work for APCM there was a .22 rifle range at the back of the stables. The stables were converted into a works clubhouse by APCM in 1958.

Converted stables to works club.

It is now owned by Woodcombe Sports.

Bowling lawn.

The clubhouse rear has been modified.

At the rear of the stables was a large stable yard surrounded by a wall, behind which was an orchard. This was converted into a lawn bowling green for APCM workers, but is now just a grass area.

On the opposite side of Church Road from the clubhouse were the club's car park and a track, which led down to the old brick earth washmill. This area was known as Happy Valley. On the right of the track there was originally a sports field, used later for growing corn. On the left was the horse's meadow.

A track to Happy Valley.

Same view now Hugh Price Close.

Happy Valley was once excavated for brick earth.

Sunny Bank houses were built on Happy Valley Sports field.

View to Happy Valley in 2008.

The road running by the side of the clubhouse was called Stable Road. The Broom Bank railway ran along here on its way to the cement mill washmill behind the houses in Church Road.

Stable Road showing Broom Bank rail tracks.

The same view in 2004.

The Stable Road led down the hill past the Reds and Pragos washbacks on the left hand side to the cement works. It can still be traced past the Wire Belt factory in EuroLink to what remains of the old road behind PJS warehouse.

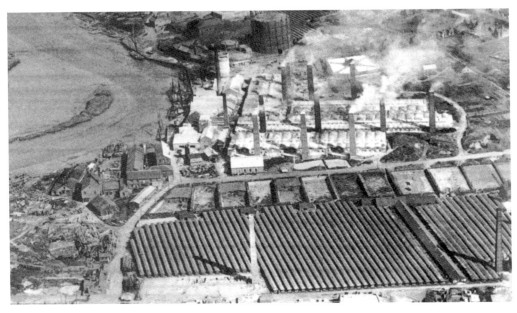

View of old Stable Road past the washbacks and old cement works chamber kilns c. 1900s.

Remains of the old Stable Road 2008.

APCM garage workshops still at the bottom of the old road.

At the bottom of Stable Road the road turned right into the cement works, past the old cement works store building occupied by Complete Tool Box and also the old works garage occupied by Sait and Sons.

It also turned to the left connecting to the old Moat Road, passing Adelaide dock and the Pragos brick plant to what was originally Muggleton's and McKenzie's brickfields, now the site of the Go Kart track.

Entrance to cart track.

There was also a road called White Road which turned right from Stable Road, just below the clubhouse, passing by the Broom Banks loco shed on the right and the works Laboratory on the left. Behind this was the cement washmill, exiting between the two blocks of houses in Gas Road. All this area is now the EuroLink Industrial Park.

From Stable Road down into Church Road was the village of Murston, with houses on both sides of the road, except for the recreation ground.

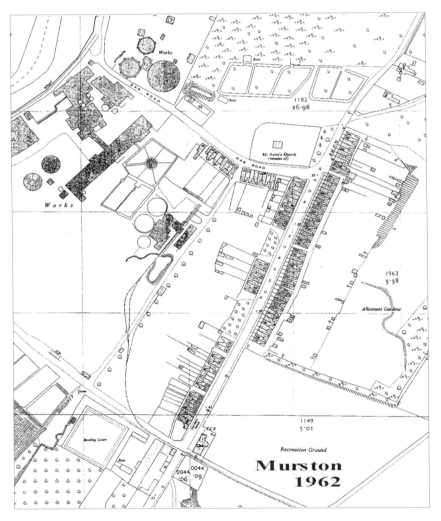

Map of Murston Village, c. 1962.

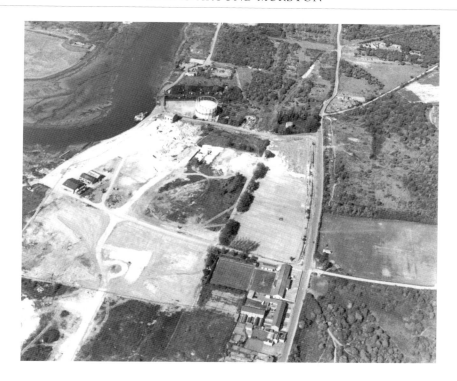

Above is an aerial view of Lower Murston showing Church Road after the houses and cement works were all pulled down. The industrial estate had not yet expanded into Lower Murston and Central Park Stadium had not even been planned. The bottom left view below the clubhouse is the cleared site of the Reds and Pragos brickfields.

Beyond the trees that lined the edge of the recreation ground, and behind the houses on the east side of Church Road, there were allotments and waste ground called the Meadows.

The Recreation Ground.

This is the same view in 2006.

The Meadows were all part of the old disused brickfields of George Smeed, and a favourite playground of Murston children. There was a line of large Elm trees left on a bank from where brick earth had been extracted. On one tree we used to attach a thick rope which was originally used for mooring barges and lighters at the creek. This we used as a swing. The rope, being about two inches thick, was strong enough for three or four to swing at one time. The grass in the meadow was kept short by grazing. A white horse named Kit, belonging to Mr Spendiff (Dicker), used to be kept on a long running chain secured to a metal pole. The trees eventually succumbed to Dutch Elm's disease and were felled. The area was at first built on to provide a new football stadium for Sittingbourne football club, but owing to difficulties it was sold and became a greyhound track.

The Three Lakes or mud holes as they were called at Broom Banks were another area playground. At Broom Banks you could get chestnuts from the coppice trees and we used to cut long poles to propel rafts that we built, using the old railway sleepers left near the old Broom Banks railway. Many hours were spent playing here in school holidays, but of course it now belongs to Sittingbourne Angling Club. The children of Murston were lucky to have all these interesting places to play, unlike today, where everything is being concreted over in the name of progress.

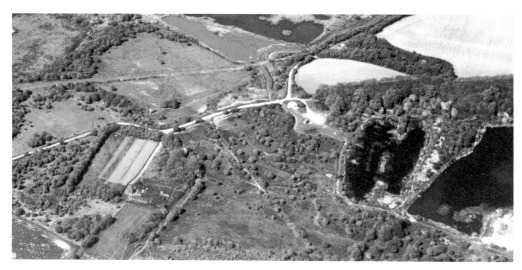

The Three Lakes on the right and Broom Banks. Notice the water looking dark compared to the water of the marsh area.

On the other side of the Village, past Gilhams shop and the post office run by Mrs Doris Field, the tarmac road ended and a dirt road led to the lower brickfield and Auto plant. This was later made into a tarmac road (*left*).

There was also a branch dirt road which forked to the right past the large garden of the detached house of the Gasworks Manager. This led to Trim Tram. The road called New Road was built by the Smeed Dean Company pre-1914, when the original roadway, which ran around Meres Farm, was destroyed by brick earth excavations. The road was built on the same route as a pathway leading to Trim Tram, crossing a field where Murston Rangers football team originally played.

New Road leading to Trim Tram.

View to what was the old brickfield road to the Auto plant.

The same view of the road which has been sealed off with concrete tubs, trying to deter illegal encampment by travellers.

At the far end of this road there were two cottages, built about 1850 for the horse keeper and groom of the old lower berth stables. This was pulled down when the new stables were built in Church Road in 1878. The cottages were occupied by their widows, Mrs Head and Mrs Carey, who were the last tenants there until the floods of 1953, when the river Swale burst through the sea wall and flooded all the low lying land, even reaching half way up the new road.

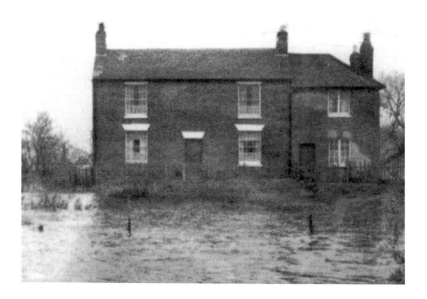

The two cottages were on slightly higher ground but the flood water was all round. The road then turned past the old Murston sewer works, now the site of a permanent gypsy camp built and opened in 1990.

From the gypsy camp, the road went on to the Tiddler pond and Broom Banks, a chestnut coppice by the Three Lakes.

The road to Broom Banks.

The stream from the Three Lakes went under the road through a brick tunnel. This was the Tiddler pond, a favourite place to find sticklebacks and tadpoles.

The road then went up a hill on its way to the ferry and Tonge Corner. Trees lined each side of the road, which made for a pleasant walk during the summer.

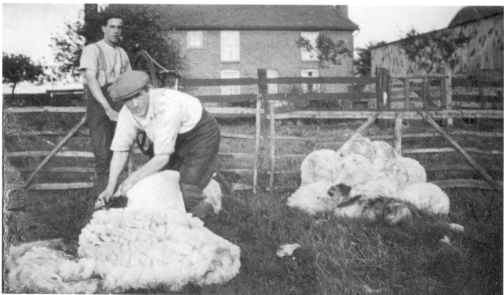

Jim Sparks shearing sheep.

Once past the Forstall, the road to the ferry turned to the left from the road to Tonge Corner. It then passed Little Murston Farm. Jim Sparks farmed here and later Manuel Beaney kept pigs there.

Little Murston Farm became uninhabited and fell into disrepair over the years, until it was bought and completely renovated.

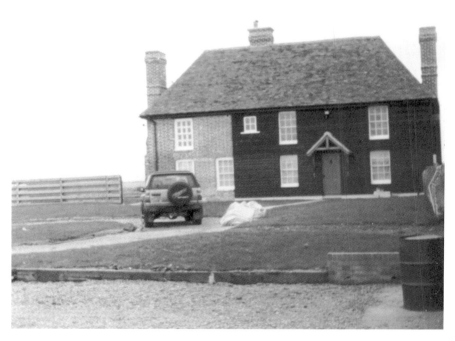

The house now transformed.

The house was then put on the market for sale. It was bought by the retired Member of Parliament, Mo Mowlem and her husband Jon Norton, in 2004. Sadly Mo passed away in August 2005 and Jon in 2009.

The road then went past Little Murston on its way to Elmley Ferry.

The road ended at the sea wall. The ferry house has now gone.

Elmley Ferry was where many hours were spent by Murstonians at weekends. The old ferry house and cottage were completely destroyed. The last residents living there were Mr and Mrs Naylor and family up until the 1953 floods. Jack Wade and family used to live in the cottage next to the ferry house. The Naylors moved to Canterbury Road Estate and Jack Wade and family moved to Gas Road, Murston.

View of Ferry House and Cottage.

Elmley at low water.

The River Swale at Elmley Ferry looking to the east at high tide.

The River Swale at Elmley Ferry looking to the west.

Remains of the two old minesweepers at the River Swale, 2009.

Each side of the sea wall is now fenced off, 2009.

From West Lane

Apart from the main road to Murston there were also other roads leading through the brickfields. One went from West Lane, the other from Crown Quay Lane. These were only dirt made roads but were used as short cuts. All this area is now the EuroLink Industrial Park.

The track from the West Lane railway arch passed the Co-op meadows on the right, where Everest glazing firm is now. The meadows were where many APCM family days were held. On the left were the Bayford orchards. A path went through these to Crown Quay Lane. Once past the Co-op meadows and orchards there were the sewer works and pumping station, now Calor Gas.

Next to the sewage works was a cottage and garden surrounded by a privet hedge. From here a slope went up past the railway siding used by Smeed Dean, and later Blue Circle. The area is now called St George's Park.

Castle Road from Island Leisure Products, on the left.

If you drew a line from the sewer works past the Island Leisure Products to half way up Dolphin Road Hill, this would be where the old dirt road through the upper field brickfields used to go, which is not quite the same route as Castle Road. It would have cut through the distant buildings on the far right.

The upper field brickfield site used to be in the vicinity of the Maco building and the building which was D&A, on the corner of the road named Upper Field Road. This was also roughly where the old engine shed was that housed the Kerr Stuart, the small steam loco which travelled under the arch at Sunny Bank to the Happy Valley washmill.

Running parallel to Castle Road is Bonham Drive, part of which was the old Moat Road that connected Crown Quay Lane to Adelaide dock. It then passed by behind the Pragos brickfield and on to the cement works wharf and the bottom of Gas Road. It also linked up to the bottom of the old Stable Road, which ran from the old stables, now Woodcombe clubhouse. There was also a junction from Adelaide dock which led back up a hill to the old road, which is now Dolphin Road. This route was from what is now Dodds Transport, up through to where the Business Post and Swale Heating buildings are, to Dolphin Road.

On the other side of the hill at Dolphin Road, built in the bank running behind the gardens of Orchard Cottages, were air raid shelters for the middle field workers during the war. A pathway between them and the Reds brickfield connected the office road (Dolphin Road) to the old Stable Road.

Dolphin Road (*right*), now a junction with Castle Road, was the old road to Adelaide dock. Castle Road, from here, passed through what were the Reds and Pragos brickfields.

Site of the Reds brickfield from Castle Road. This is next to Johnson's factory at the bottom of Dolphin Road hill.

Site of the Pragos brickfield behind Able Glass factory.

Castle Road then crosses the route of the old Stable Road which ran between Loafers café (site of the washbacks) and the Wire Belt Company, the site of the old cement chamber kilns, which was dismantled with explosives in 1947.

Loafers café next to the Wire Belt Company.

Castle Road then progresses past the site on the left of D2 Trading Estate, which was the site of the cement works, then on to the roundabout at Gas Road and Stadium Way.

The new buildings on the right hand side before the roundabout are where the cement washmill and testing laboratory were situated.

The D2 Trading Estate.

Former site of the cement washmill and testing laboratory.

At the Gas Road/Stadium Way roundabout, the building being erected on the left side was where the wooden water cooler stood and also the drying ground hacks of the brickfield that were behind it.

On the right behind the old church, two new office blocks have now been built on what was waste ground, where there was originally a farm prior to Smeed's brickfields.

The road then passes by the office buildings and new warehouses, built behind the old Murston church, which is all on part of the old lower field hand berth brickfields.

Then the road winds past Carousel Warehouse and on to Flo Plas towards the roundabout, which will form part of the Northern Distributor Road.

Carousel Warehouse on the right of Castle Road.

On the left side of Castle Road, just before Flo Plas, is a large packaging factory, once called Macleod McCombe. This closed and another firm, Cross and Wells Ltd, has occupied the factory.

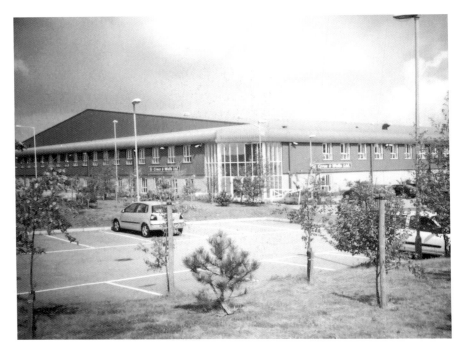

The Flo Plas factory surrounded by fencing.

At the roundabout the road turns to the right, which is Swale Way. This leads towards the gypsy site and will be the Northern Distributor Road.

On the left of the roundabout there are gates at present, where the road will cross the creek by a bridge, to link up with the other part of Swale Way at Grovehurst and the A249 Sheppey dual carriageway.

The creek was surveyed in 2005 during research for the bridge.

Surveying on the east side at Murston.

Surveying the west side at old Burley's wharf.

View along the creek past the Brickmakers Arms, showing the survey rig.

View of Burley's wharf where the bridge will be likely to cross.

From the other side of the roundabout at the junction of Swale Way, the road passes by Marshalls Block Paving plant. This was built on the site of the Auto Brick plant's old clamp kiln building, which Blue Circle originally turned into a paving plant but was never used. The machinery was dismantled and sold.

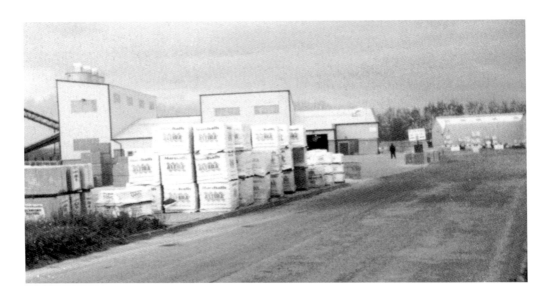

Marshalls has since bought up quite a lot of the Auto plant site, including the garage, stores building and the office which stood on the Auto entrance road. This road is now closed and used as an extended stack yard and a new entrance road was built for the Brick plant. The road to the right of this was built on the old dirt track to Trim Tram, along which more factories are being built.

The road from the last roundabout in Castle Road has now been extended further into the industrial and housing estate (*above*).

The picture below shows the start of the proposed extension where an earth bank was built, raising the ground level for the road in 2004.

The road was started in 2005.

The kerb stones were also laid in 2005.

A view from the rear of East Hall where there were two bungalows. These were for the farm workers accommodation. This area is now where the distributor road will run through.

A later view when the road was extended to East Hall.

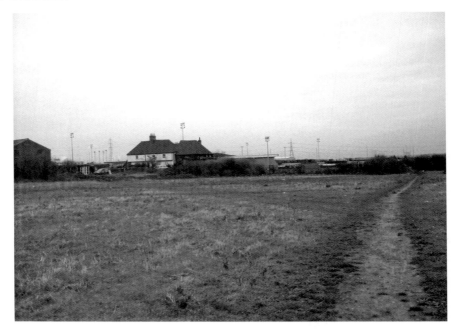

This was the area at Meres Court farm after farming ceased and before the development started for the EuroLink East industry.

The same view cleared for development.

The start of development, looking towards the farm.

The road being laid for the EuroLink East industrial site.

The road part of the Northern distributor link named Swale Way was completely laid by June 2006.

The sign showing Great Easthall, the housing development and the road to EuroLink East, the industrial units behind Meres Farm.

From the roundabout the road progresses to Easthall and turns right into EuroLink East.

The road into EuroLink East industrial site.

Great Easthall, the start of the new housing development, will stretch from East Hall Farmhouse, across the fields and old allotment site that was along Lomas Road/Tonge Road near the railway line.

The first houses to be erected which will be show houses for buyers to view.

View of show houses from the roundabout.

The two show houses ready for viewing opened in 2006.

A balance pond (*above*) was dug to the south east of Easthall in front of the houses. This is for the estate's road drainage, which would then flow out through culverts to the marsh area. Most of this area is low lying.

A view of the completed houses from the roundabout.

From the roundabout the road turns right to the show houses.

The picture above shows how the area looks in 2008 now the houses are built. The balance pond is well established showing the outlet culverts.

From the new houses (*below*), a new road is being built from the balance pond towards the old Tonge Road allotment site, where further extension of Great Easthall is proposed.

Tonge Road allotment site viewed from my allotment. *My allotment was one of the last remaining in 2003.*

The old allotment site at Tonge Road, now overgrown, is where more houses will be built.

Derelict allotment site viewed looking east.

The site being cleared ready for development.

Same view now cleared.

Pathway leading to allotments from Oak Road.

Opposite the path there was originally an orchard of Easthall farm. This will be the site of proposed housing development called Great Easthall.

A bus route and cycle path only, built from Oak Road, leading to what will be Great Easthall.

The houses being erected on the old allotment site.

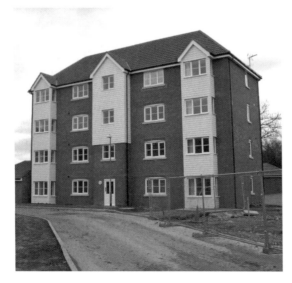

Top: *The completed bus and cycle route with traffic lights and 'no entry sign', except for buses only.*

Above: *The road from the bus route into Great Easthall.*

Left: *Block of apartment flats built on the allotment site.*

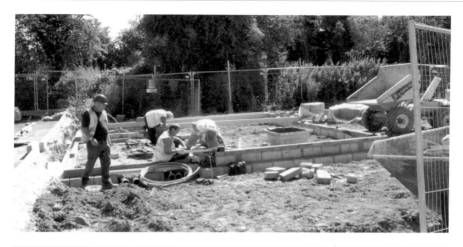

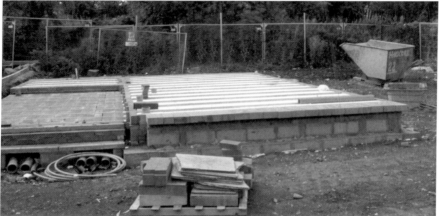

Top: *Start of ground work on my old allotment.*

Above: *The foundation and flooring laid down.*

Right: *House erected 2008.*

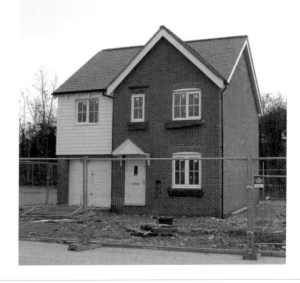

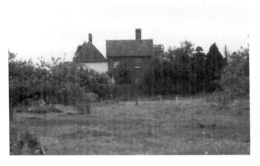
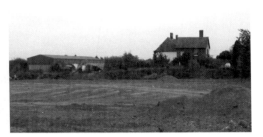

Above left: *A proposed new allotment site was to be built on the Easthall farm orchard at the side of the farm house.*

Above right: *Clearance began in 2005.*

Below: *After the site was cleared a fence was erected.*

Bottom: *The site was completely fenced with entrance gates off Meres Court Lane.*

Start of the new allotments.

Cultivated allotments viewed from Meres Court Lane.

12
Past Residents of Murston

The old village of Murston has now disappeared and is just a distant memory, but photographs are a window to how life in the community existed in years gone by.

The Murston Brass band, c. 1910.

Murston Scouts, c. 1915.

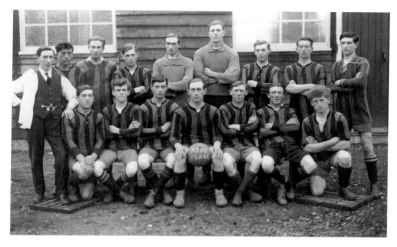

Murston Rangers, 1920.

Murston had two football teams which played in the Sittingbourne and Milton District league during the 1920s. Murston Rangers were in Division 1 and the Reserves in Division 2.

Players included H. Hammond, H. E. Hammond, F. Hammond, R. Hammond, T. Shrubshall, A. Nash, E. Nash, F. Nash, T. Wilcock, B. Hills, P. Hyland, H. Priston and S. Dungey.

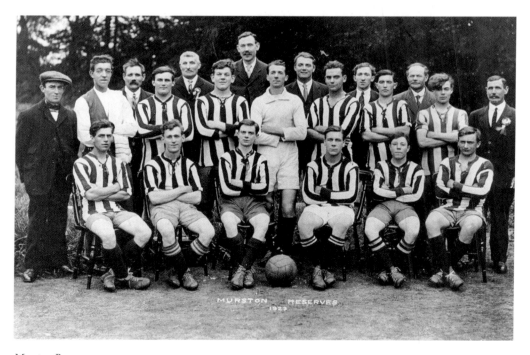

Murston Reserves, 1923.

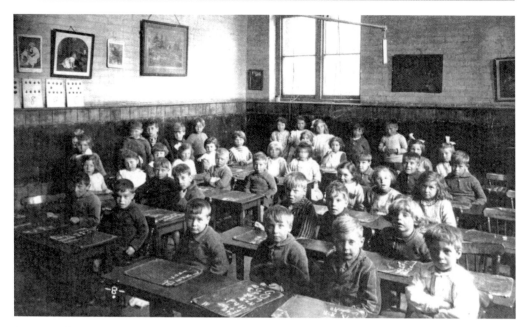

Murston Infants, c. 1925.

Surnames of children above include Drake, Wiley, Thomsett, Bowra, Wratten, Jarrett, Hollister, Brooks, Watson, Hammond, Cooper, Spendiff, Houghting, Whitehead, Wanstall, Foord, George, French, Cockle, Mount, Long, Read, Wood, Edwards and Brenchley.

Surnames of Ms Sedge's class below include, Hassam, Sawyer, Ganden, Blunt, Symonds, Kemsley, Jenner, Brown, Middleton, Landen, Hudson, Eley, Williams, Dowset, Anderson, Kitney, Chappel, Harvey, Bareham, Stevens, Spice, Jeffrey, Fisher, Richardson, Barney and Clinch.

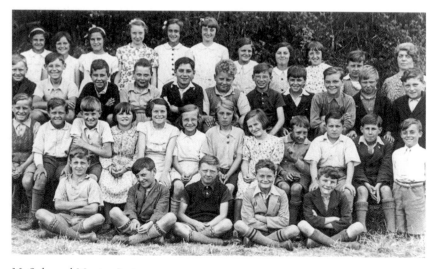

Ms Sedge and Murston Juniors, c. 1937.

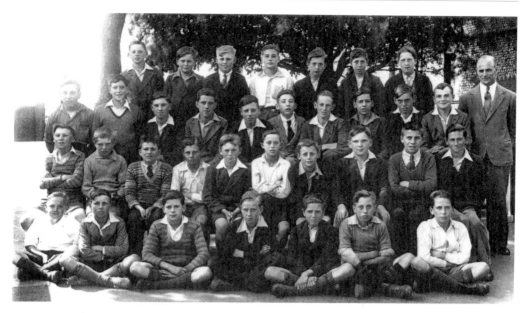

Master Tom Coleman and class of 1933. Standard 6-7.

Back row left to right: Hart, Tomsett, Watson, Mills, Harding, Edwards, Waters.

Second row: Brooks, Harman, Kemp, Wanstall, Ward, Coleman, Houghting, Court, Brenchley, Clinch, Teacher Mr Coleman.

Third row: Bowra, Jarrett, Chittenden, Hawkins, Long, Wiley, Young, Unknown, Whitehead, Drake.

Front Row: Birkett, Watson, Luckhurst, Read, Dawton, Streatfield, Fletcher.

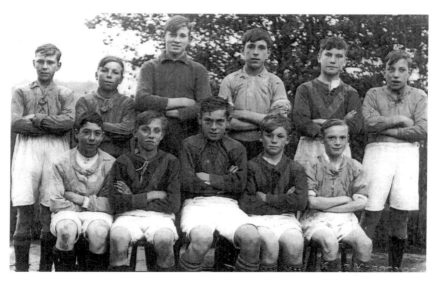

The same class football team.

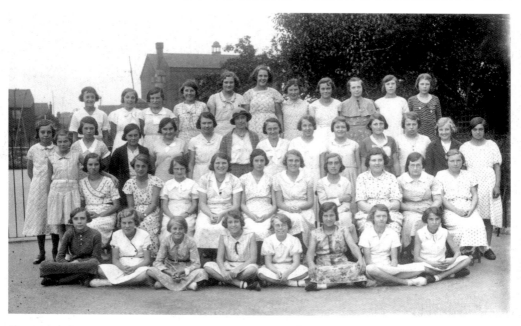

Mrs High and Murston Girls, c. 1935.

Girls viewed from left to right:

Back row: first unknown, Marge Brooks, unknown, Mavis Sivier. The next seven unknown.

Second row: first four unknown, Mavis Hammond, Phyllis Kitney, Mrs High (Teacher), Dolcie Symonds, Mary Banks, unknown, Kitty Gates, Vera Ward, next two unknown.

Third row: Doris Ward, next two unknown, Joan Vanderpeer, next two unknown, Joyce Spearment, Gladys Sellen, Florrie Lacey, unknown.

Front row sitting down: all unknown except the third girl from the left who is Syble Feaver.

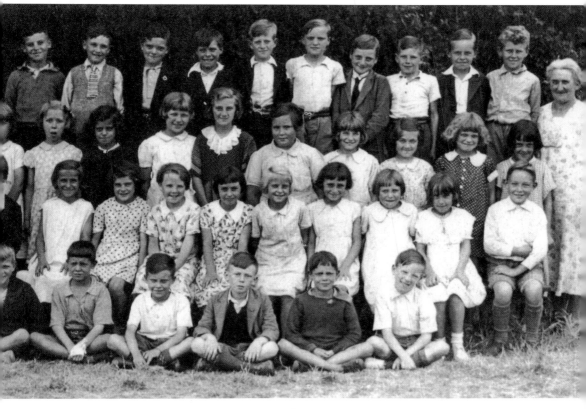

Murston School, Ms Packer's Class, c. 1937.

Class left to right:

Back row: Ken Ward, unknown, Brian Hollands, Derek Bareham, Ron Ivory, Aubrey Snashall, Webb, Ray Edwards, Peter Borman, Brian Attwater.

Second row: Betty Rose, Eve Jenner, Eady Dowel, Betty Ward, Linda Hudson, Betty Bridges, Linda Harris, Hazel Jordan, Brenda Ince, Betty Brunton.

Third row: Ron Mannouch, Mildred Rumley, Rose Chappell, Doreen Gambell, Beryl Reid, Grace Martin, Rosemary Bodkin, Molly Gransden, unknown, Bob Otterway.

Sitting down: Charlie Warner, Cyril Watts, Bernard Hills, Ronnie Rochester, Ronnie Watts, Peter Cowles.

Bibliography

Andrews, George *Memories of Murston* (1930)
Hasted, Edward *The History and topographical survey of Kent* (first published 1778)
Luman, June *All Saints' Parish Church*
Perks, Hugh *George Bargebrick Esquire: George Smeed, 1812-81* (1981)
Sittingbourne and Milton 1908 Directory.
Twist, Syd *The History of Murston Village and Parish.*

I also made use of the following sources and institutions in my research:

The *East Kent Gazette.*
The Centre for Kentish Studies.
Sittingbourne Library.

Acknowledgements

I would like to thank my daughter Caroline Stratford who kindly proof read. Also to those who helped with information including Chris Bromwich, Lynn Jones, Dot Bromley, Ray Hills, Don and Eileen Ward, and Roy Wellard.

I wish to thank the following for permission to reproduce photographs contained in this book. Every effort has been made to trace the known copyright owners. The numbers refer to picture numbers.

Photographic Plates

Iris Stevens Nos. 3, 4, 6, 16, 17, 33, 49, 50, 135, 136, 147, 150, 151, 155, 157, 159, 161, 162, 165, 171, 172, 298, 299, 300, 301, and 303; Max Houghting Nos. 302, 304, and 305; Mrs Sivier No. 10; Arthur Woodhill No. 13; Frank Phipps No. 21; East Kent Gazette Nos. 27 and 38; Rene Pitts Nos. 34 and 306; Centre for Kentish Studies No. 46; Kent Archaeological Society Nos. 47 and 48; Bill Lee No. 63; Maureen Phipps No. 88; G. Alliez No. 126; J. Bonser Nos. 127 and 132; Frank Holmes No. 145; R. D. Kidner No. 182; Aerofilms No. 203; Rene Smith No. 220; Raymond Naylor Nos. 2 and 225; Ron Mannouch No. 307.

Blue Circle Nos. 8, 11, 66 – 69, 98 – 109, 121 – 125, 129 – 131, 133 – 134, and 207 – 210.

Blue Circle's photographs were taken by Les Moore, Ronald Chapman, The Fine Art Studio and aerial photographs by Handford Photography.

The rest of the pictures are from my own collection.

About the Author

 I have lived in Murston all of my life and worked in the local brickfields. I am married with two children and have two grown up grandchildren.

I was educated at Murston School and Sittingborne West Secondary School. I started work at fifteen years of age for APCM. Later the name changed to Blue Circle.

At eighteen years of age I joined the army, serving for three years in the Royal Mechanical and Electrical Engineers as a vehicle and plant electrician.

On leaving the forces, I worked for a short while in the local paper mill before returning to the brickfield. I was made redundant in 1963 and worked in various employments, until returning to the brickfield in 1970 and continuing there until my retirement. I have various hobbies in which I enjoy stamp collecting and researching family history.

My wife and I were also amateur ballroom dancers attaining medals and IDTA national awards.

Since retiring I joined the local historical research group society and decided to write this book.